TAXIDERMY ART

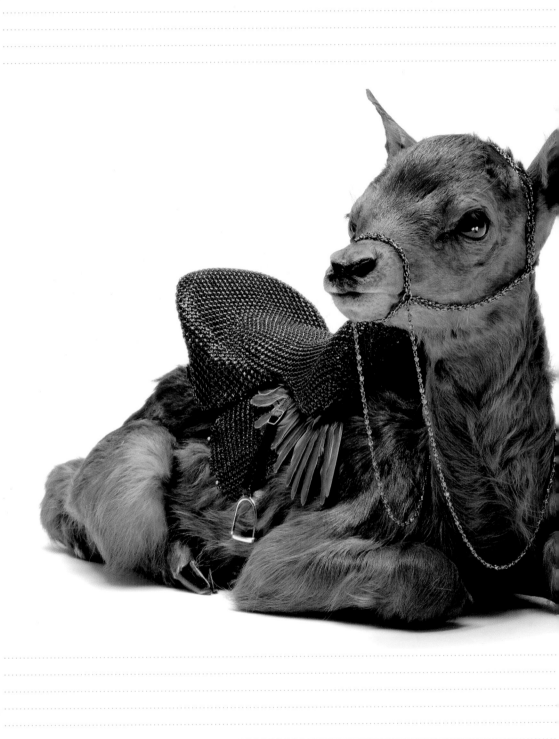

TAXIDERMY ART

A ROGUE'S GUIDE TO THE WORK,
THE CULTURE, AND
HOW TO DO IT YOURSELF

ROBERT MARBURY

ARTISAN

Published by Artisan
A division of Workman Publishing Company, Inc.
225 Varick Street
New York, NY 10014-4381
artisanbooks.com

Published simultaneously in Canada by Thomas Allen & Son, Limited.

Library of Congress Cataloging-in-Publication Data is on file.

ISBN 978-1-57965-558-7

Design by Kara Strubel

Frontispiece: *Actaeon* by Julia deVille
Endpapers: Photograph by Arsgera/shutterstock

Printed in Singapore

First printing, September 2014

10 9 8 7 6 5 4 3 2 1

CONTENTS

INTRODUCTION

n 2004, artists Sarina Brewer, Scott Bibus, and I established the Minnesota Association of Rogue Taxidermists (MART). What began as a consortium of three local artists interested in natural history and the showmanship of oddities quickly grew into the first international organization devoted to the medium of Rogue Taxidermy (a term first coined by MART).

Since that time the community of Rogue Taxidermists and taxidermy artists has expanded considerably. Do-it-yourself workshops have popped up in cities from Los Angeles to London, as well as in oddities shops in between. Not since the Victorian era has taxidermy been so popular.

This book has been created to address this growing interest and to serve as a source of information and inspiration, from highlighting key figures in the development of taxidermy and showcasing the most exciting artists working in this medium today to providing workshops that can serve as jumping-off points for developing your own practice.

It is an exciting time for Rogue Taxidermy, with more resources and channels available to explore than ever before. Social media have allowed taxidermy work, art, and ideas to be shared in real time, all around the world. And if you have an interest in creating art with taxidermy or taxidermy-related materials, there is no better, or easier, time to start than now.

So without further delay, let's jump in.

A TAXIDERMY PRIMER

What Is Taxidermy?

From the ancient Greek *taxi* (to arrange) and *dermis* (skin), taxidermy is the preservation of an animal's skin, fur, or feathers, and sometimes teeth, horns, and beak. A mount might contain bones—to help re-create the animal's form, proper size, and articulation—but more than likely the interior will be filled with foam, resin, wood, plaster, or clay. (The muscle tissue and internal organs are removed, since they rot and smell quickly.) Taxidermy mounts are most commonly used as interior decoration, as a trophy from a hunt, or as a natural history specimen.

A Brief History

The first examples of animal preservation were the ancient Egyptians' mummified pets, including cats, birds, and even gazelles. It wasn't until the fourteenth and fifteenth centuries that a crude form of taxidermy was developed when mounted and stuffed birds were used as decoys by falconers to lure birds of prey into their traps. For the next few centuries, most animal taxidermy, whether for scientific or trophy purposes, could be viewed as little more than upholstery work, with the skin simply stretched over wood or stuffed with rags and cotton. No real attempts were made at pest control or tanning. In the sixteenth century, a growing interest in the natural world led European princes and scholars to display animal specimens in their cabinets of curiosities (precursors to modern museums). As the taxidermy pieces became objects of interest, techniques were developed to repair, maintain, and better preserve the skins.

It wasn't until the end of the eighteenth century, however, with the development of arsenic soap, that a truly effective preservation method was developed. Although arsenic went out of fashion in the mid-1960s because of the poisonous effects of prolonged contact, there is no doubt that its use allowed the profession of taxidermy to flourish. By the time the first professional taxidermist business, Rowland Ward Ltd. of Piccadilly, opened in London in 1898, there was enough demand for hunting mounts that almost every town had a tannery that practiced taxidermy with some degree of success.

The height of taxidermy's popularity may have come during the Victorian era. The 1851 Great Exhibition at the Crystal Palace in London featured many taxidermy specimens, including English taxidermist John Hancock's *Struggle in the Quarry*, featuring a gyrfalcon attacking a heron grasping an eel. A major attraction at the exhibition, his

mounts realistically portrayed the animals in action, something that taxidermists had not been able to achieve up to this point.

Around this same time, American taxidermists Martha Ann Maxwell, Carl Akeley, and William Hornaday began to showcase animals in their own worlds. It was thought that this would allow the viewer to be better able to relate to the creatures and therefore feel a desire to protect them and their natural habitats. Once hugely popular in natural history museums, habitat dioramas have been edged out, replaced by multimedia exhibits that draw in larger crowds and greater revenue.

Trophy mounts continue to be a profitable taxidermy venture. Hunters who wish to memorialize their expeditions are prepared to pay a premium for the best possible results, and the business behind trophy mounting continues to motivate technical developments and the increasing availability of taxidermy and taxidermy materials. The last decade has seen an increased interest in taxidermy far beyond the hunting lodge, however. Thanks to interior decorators and fashion designers, restaurant owners and art dealers, the visibility and demand for taxidermy have exploded.

Taxidermy and the Law

Taxidermy and conservation are perpetually linked, and the laws that govern both have been created to aid both the profession and the animals. Knowing and following these laws protects you, protects the animals that are restricted, and protects the taxidermy community in general. While it can be challenging to get answers to questions that fall in the gray areas of animal legislation, there are laws that every artist working with animal parts must know—ignorance is never an acceptable excuse. (See Legal Resources, page 229, for a full list of websites that explain the laws governing animal stewardship.) Here are the six key pieces of legislation that affect taxidermy:

Convention on International Trade in
Endangered Species of Wild Fauna and Flora (CITES)
CITES is a multinational treaty that protects endangered animals and plants. The largest multinational conservation agreement, it has three appendixes. CITES I covers 1,200 species of animals and plants that are threatened with extinction. CITES II covers 21,000 species of animals and plants that may become threatened with extinction due to trade. CITES III covers 170 species of animals that individual nations protect. CITES deals primarily with the international transportation of illegally killed

or possessed animals. (If the trade can be stopped, then poaching will be devalued.) This legislation affects anyone who buys or sells mounts, skins, or animal parts *internationally*, but trading an animal on this list *anywhere* requires a CITES tag to prove where it came from and how it got to you.

Migratory Bird Treaty Act of 1918 (MBTA)

This act applies to 800 species of migratory birds and protects birds both living and dead, as well as their eggs, nests, and feathers. MBTA replaced the Weeks-McLean Act, which was enacted in 1913 to combat the growing popularity of using migratory bird feathers in women's hats. The United States, Canada, Great Britain, Mexico, Japan, and Russia have all incorporated treaties under MBTA.

Lacey Act

The Lacey Act of 1900 prohibits the transportation of illegally obtained or possessed animals across state lines. A 2008 amendment prohibits the importation and trade of potentially dangerous nonnative species. While this wildlife law primarily affects hunters, it also pertains to those who purchase skins or animal parts across state and federal lines.

Marine Mammal Protection Act

This act protects 125 species of mammals, including whales, dolphins, porpoises, seals, sea lions, and walruses.

Endangered Species Act

This conservation law was established by the United States government to protect animals deemed endangered. It restricts the killing, trading, and selling of the animal

CANYON

In the mid-1950s, painter and artist Robert Rauschenberg began to make artwork described as "Combines." Picking up pieces of ephemera from the streets of New York City, Rauschenberg would combine them with his paintings. Among these Combines are several that contained taxidermy animals—most notably *Canyon*, which included a bald eagle.

Because it contained a bald eagle, *Canyon* violated both the Migratory Bird Treaty Act of 1918 and the 1940 Bald and Golden Eagle Protection Act—meaning that it was illegal to buy, sell, trade, or even possess this artwork. The piece remained under the radar until 2007, when its then-owner, Ileana Sonnabend, died. Sonnabend's heirs inherited a collection of art valued at around $1 billion. Since *Canyon* could not legally be sold, it was assigned no value (and thus, the heirs were not required to pay estate taxes on the piece). However, in 2011, the IRS reviewed the case and consulted its Art Advisory Panel, which assigned *Canyon* an "artistic value" of $65 million—meaning the heirs owed the government millions of dollars, though they were unable to legally sell the work. Ultimately an agreement was struck wherein the heirs were able to donate the piece to the Museum of Modern Art (for which they would receive no charitable donation tax break), and in so doing eliminate their debt to the IRS.

or parts of the animal. For taxidermists, this means that certain animals are never allowed to be collected, mounted, or sold. The ESA is administered by the United States Fish and Wildlife Service (FWS) and the National Oceanic and Atmospheric Administration (NOAA).

Bald and Golden Eagle Protection Act

This act was established in 1940 to protect the United States' national bird after the increased use of DDT (dichlorodiphenyltrichloroethane) and overhunting put the population at risk. It was expanded in 1962 to cover the golden eagle. This act not only protects the eagles, but also makes it unlawful to possess their feathers or eggs, and even to harass them. Because of the high number of eagles killed each year by wind turbines, this act is currently being challenged by wind energy groups.

Rogue Taxidermy 101

Rogue Tax·i·der·my [rohg TAK-si-dur-mee] *A genre of pop-surrealist art characterized by mixed-media sculptures containing traditional taxidermy materials used in an unconventional manner*

Taxidermy in all of its forms is a sculptural storytelling technique. But while a traditional mount tells an archetypal story of an animal, an artistic mount is meant to represent a subjective narrative. For example, a bear that is mounted traditionally is meant to represent a bear. But when Rod McRae mounts a polar bear on a refrigerator (page 86), the bear is a commentary on global warming. And when Mark Dion mounts an artificial bear in a den installation (page 106), the bear becomes a commentary on the history of that place.

Untraditional taxidermy is not new. Sailors in the sixteenth century cut and preserved skates and rays in a devilish form called the Jenny Haniver (this early gaff was commonly included in cabinets of curiosities). Anthropomorphic taxidermy gained popularity in the Victorian era, when taxidermists like Hermann Ploucquet, Walter Potter, and Edward Hart used animals in human poses and situations to tell decidedly unnatural stories. In the early twentieth century, Dadaists, Surrealists, and Postmodernists like Joseph Cornell, Joan Miró, Méret Oppenheim, Victor Brauner, and Robert Rauschenberg set the stage for contemporary artists by introducing taxidermy and taxidermy-related materials into their artwork.

Since then, the impulse to create provocative, unexpected art using taxidermy has only grown stronger—and the launch of the Minnesota Association of Rogue

Taxidermists has helped bring ethical accountability to the forefront of the increasingly popular medium. Here are a few major societal shifts that may account for taxidermy art's sudden ubiquity.

A Return to Craft

The technological developments of the past twenty years have all but eliminated the importance of craftsmanship in consumer goods. Not surprisingly, there has been a backlash against this shift, with many people striving to be self-sustaining by rejecting mass production and instead embracing physical labor and handmade goods. Taxidermy joins yarn bombing, bookbinding, and pickling as expressions of this handwork revolution, and an alternative economy has developed to handle the influx of handmade goods (as seen on sites like Etsy, eBay, Pinterest, Behance, and Instagram). And as these crafts gain traction in popular culture, there are those who find a way to elevate them. *Handwork* begets *artwork*, and movements like Rogue Taxidermy are born.

Emergence of Collecting

Whether it's sports memorabilia, hobo nickels, or Pez dispensers, people love to collect—and show off their collections. And this hobby (compulsion?) has become easier than ever, in large part thanks to sites like eBay and Craigslist. No matter what you're collecting, the rarer it is, the more it is valued. This makes taxidermy a particularly alluring prospect—by its very nature, no two pieces can be exactly alike, and thus each piece is endowed with an unmatched aura of authenticity. This is especially true of artistic and gaff taxidermy, which, unlike traditional taxidermy, strives not for the Platonic ideal of the animal, but for singularity.

Further contributing to taxidermy's rarity, and thus its appeal for a collector, is that its inherent instability makes collecting older pieces quite difficult. In order to be handed down, antique mounts have had to survive decades of bugs, misuse, weather, and fire. This has driven up the price for antique finds and allowed for a robust and profitable market for *new* taxidermy, which has grown to fill the demand.

And collecting gives rise to new taxidermists as well. As people begin to collect, many eventually learn the techniques needed to maintain their collection. Mounts can be eaten by bugs or split at the seams, pickled specimens require new liquid, and bones can break. And so, invested collectors will often take it upon themselves to fix their own collections—sometimes, when they get the hang of it, becoming creators in their own right.

The Internet

Rogue Taxidermy is truly a digital movement—growing from three artists working in Minneapolis to an international community thanks to the Internet's unique ability

STONED FOX

When artist Adele Morse had the idea to make a sculpture of a little boy wearing a fox Halloween costume for her arts university review, she had no idea the lengths to which this idea would take her. After receiving a fox skin donation just a week before her art critique, Adele rushed her first attempt at tanning and tried her best to repair the damages to the fox's face. After seeing the results, she declared the sculpture a failure—albeit one with a certain something. For two years, the fox sat in Adele's studio. But when she decided to put the fox up for sale on eBay, everything changed.

Interest in the fox began in Russia and soon spread to bordering countries. It became a meme, Упоротая лиса (Stoned Fox), and showed up in Photoshopped scenes with Putin, Obama, and DiCaprio. Adele and her fox entered the Russian news circuit and eventually were invited to a gallery, resulting in a press tour. Adele is still not sure what exactly prompted the *Stoned Fox* obsession, but she is happy to have had the experience. As for the *Stoned Fox*, money was raised to borrow the piece from its new owner for an extended stay in Russia.

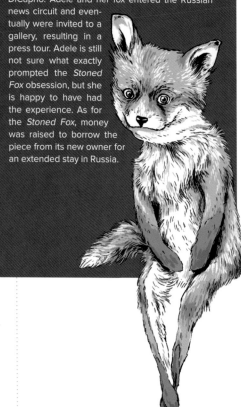

to bring like-minded people together. MART gained notoriety when, in 2005, *The New York Times* ran an article about our group that quickly went viral. Since then the digital reach of Rogue Taxidermy has continued to grow: Taxidermy tutorials are more readily available than ever before, social and user-generated media allow artists to share their artwork, and real-time exchanges of ideas on an international scale are increasingly common. Where legal restrictions and the high cost of transportation might have kept art objects localized in the past, the digital reach of Rogue Taxidermy has fostered a great enough demand to establish international exchanges, traveling taxidermy art classes, and art shows from Brooklyn to Berlin.

Whatever form of bio art they practice (taxidermy, preservation, mummification, esodermy, osteology, or "vegan taxidermy"), the incredibly diverse community of Rogue Taxidermists have a few things in common. They tackle issues of conservation, stewardship, and animal representation with absurdity, humor, and beauty, and their pieces tell complex narratives that are only possible using taxidermy and taxidermy-related materials.

A NOTE ON ETHICS: The impulses and interpretations of taxidermy artwork vary internationally, as do laws and attitudes toward animals. No matter where you live, working with animal remains is complicated. The founding tenet of MART was that our group would search for a way to make the practice of using animal parts in art ethical. We developed an Ethics Charter that prohibits members from killing animals

for the purpose of their work. It also encourages them to: reduce waste by using as much of the animal as possible; follow local, national, and international wildlife laws; develop a dialogue about taxidermy art (especially with critics); and actively take part in the conservation and care of animals. Aspects of taxidermy artwork may make people uncomfortable, but the point is never to be ostentatious or deliberately offensive. Every piece is the artist's expression of his or her love and wonder of animals, and none of the artists involved in this book contributed to the death of any animals for their work.

THE
CANON

Pioneers in
Natural History,
Taxidermy, and Art

ere are the innovators, geniuses, and madmen who were pioneers in natural history, traditional taxidermy, and taxidermy art. These men and women provided the essential foundation for contemporary work in the fields of taxidermy and taxidermy art.

PLINY THE ELDER

AD 23–AD 79

Pliny the Elder, lesser known as Gaius Plinius Secundus, was a Roman army and navy commander, author, philosopher, and naturalist. His epic work, *Naturalis Historia,* consists of 160 volumes and was an attempt to collect all of ancient knowledge. Fortunately for Rogues, Pliny the Elder dedicated many pages of his work to oddities like Cylops, the basilisk, the unicorn, and the kraken. (He drew the line at werewolves, however, which he dismissed as unscientific.) His observations, fictional and otherwise, provide a rich resource for mythical taxidermy artists.

RUDOLF II

1552–1612

When you are born to the House of Hapsburg and are destined to be the Holy Roman Emperor, King of Hungary and Croatia, King of Bohemia, and Archduke of Austria, you have a few options: You can commit yourself to ruling and building power, you can wait to be murdered, or you can focus on your own interests and let the affairs of state work themselves out. Rudolf II chose the latter, creating the most extensive and skillfully curated *Kunstkammer* (art collection) of his time and transforming Prague into an international center of culture. His collection became an encyclopedic resource for seventeenth-century European academics and established the studies to preserve animals through taxidermy, wet preservation, osteology, and drawings. After Rudolf II's death, the *Kunstkammer* was dispersed, looted, and auctioned off. Pieces of the collection can be found in museums all over Europe and the United States and continue to inspire taxidermists and artists the world over.

OLE WORM

1588–1655

Olaus Wormius was an academic, physician, and collector born into a wealthy family in Copenhagen. His inherited wealth afforded him an

extended education and enabled him to amass a unique and extravagant collection of natural curiosities and taxidermy animals, including an alligator suspended from the ceiling, a unicorn horn (which was really from a narwhal), and a great auk. Known as Museum Wormianum, this collection was illustrated in detail in a catalog published after his death called *Worm's Museum, or the History of Very Rare Things, Natural and Artificial, Domestic and Exotic, Which Are Stored in the Author's House in Copenhagen.*

Ole Worm's collection continues to influence contemporary artists. In 2003, Rosamond Purcell set out to re-create his museum, constructing a room and all of the objects visible in the original catalog print. In 2011, the piece was installed as part of an exhibition, All Things Strange and Beautiful, at the Natural History Museum of Denmark, returning Worm's Museum to Copenhagen 350 years after its original creation.

FREDERIK RUYSCH

1638–1731

Frederik Ruysch was the forensic inspector of Amsterdam and an expert in preserving tissues and organs. His advanced preservation solutions provided the basis for preservation techniques still used today, but it is his odd artistic flare that is his biggest influence on contemporary bio artists. When preserving anatomical specimens, he would add lace to a disembodied arm or around the neck of a child's severed head, as if to let the body part retain an element of its humanity. Ruysch also created miniature allegorical tableaux with fetal human skeletons placed in landscapes created out of hardened veins and arteries in place of trees and bushes. His anatomical collections live on, but unfortunately his allegorical tableaux survive only through illustrations.

ALBERTUS SEBA

1665–1736

Albertus Seba was an apothecary in Amsterdam, but his real passion was collecting oddities and curiosities from foreign lands. He frequently met ships in port and offered the sailors medicine in exchange for specimens, enabling him to collect dozens of drawers full of shells and European insects and hundreds of jars of animal specimens. After selling his first collection to Peter the Great on the tsar's visit to Amsterdam, Seba proceeded to amass an even larger assemblage of marine animals, insects, and reptiles. Seba dutifully cataloged his many collections, and these illustrated catalogs were instrumental in creating a history of natural objects and established a protocol for documenting flora and fauna that naturalists use to this day.

Seba was a key figure in the transition from *Kunstkammer* to modern museums of natural history. Not only did he literally transfer collections between the wealthy and the newly forming museums, but his illustrations also represent a snapshot of the culture and ideas of this time of great intellectual change. Surviving pieces of his collection are included in the Zoological Institute of Saint Petersburg, the Natural History Museum in Stockholm, the Zoological Museum in Amsterdam, and the British Museum in London. In 2001, Taschen published a 636-page, coffee-table book entitled *Albertus Seba's Cabinet of Natural Curiosities* based on illustrations of his collection.

CHARLES WILLSON PEALE

1741–1827

Charles Willson Peale was a portrait painter, a naturalist, and a pivotal figure in American history. He painted major figures of the American Revolution—including George Washington—but his greatest accomplishment was the creation of the first museum in America. Peale's Museum was located in Philadelphia, and with an annual ticket price of one dollar, it was accessible to everyone from presidents to merchants. Thanks to him, artifacts that were once relegated to the curiosity cabinets of the rich became available to the public, and America's rich natural history was showcased for the first time. When P. T. Barnum bought a majority of the original collection for his American Museum in New York in 1842, its popularity proved that natural history and taxidermy collections were not just worthwhile academic pursuits—they could draw an audience. Peale's vision was integral in the development of today's art museums, museums of natural history, circuses, sideshows, and oddity collections.

CHARLES WATERTON

1782–1865

Charles Waterton was a wealthy naturalist, taxidermist, and rabble-rouser, known for antics including riding a caiman crocodile, "navigating the atmosphere" by jumping off of roofs, and frequently attacking other naturalists in the press. A Rogue Taxidermist ahead of his time, Waterton's gaff work and taxidermy grotesques were the first examples of taxidermy used as a medium for social and political critique in the press. In *Nondescript,* he modeled the rear end of a monkey to resemble a disagreeable tax agent. In *Martin Luther After the Fall,* he denigrated the Protestant Church by depicting the reformer as a bedeviled, squat, apish creature with crossed arms. And like a political cartoon brought to life, his tableau *John Bull and the National Debt* featured a tortoise-shelled, human-faced porcupine being overcome by devils as it is

weighed down with sacks of money. Waterton's experimental taxidermy techniques inspired generations of future taxidermists. In fact, he taught his techniques to a former slave named John Edmonstone, who would later teach the art to Charles Darwin. His work can still be seen at the Wakefield Museum in Yorkshire.

JOHN JAMES AUDUBON

1785–1851

Around 1820 illustrator John James Audubon began to work on what would become his ornithological masterpiece, *Birds of America*. During the first six years of this project, Audubon (with his assistant Joseph Mason and, later, with Swiss painter George Lehman) observed birds in the wild, hunted them, and then mounted the birds as reference while he drew and painted them. His artistic drive and devotion, as well as his skilled observation and reproduction, has inspired generations of taxidermists and natural history artists to produce more lifelike work.

The original edition of *Birds of America* was approximately fifty inches tall and featured seven hundred hand-colored, life-size portraits of North American birds. In 2010 a copy of the Double Elephant folio sold at Sotheby's for £7,321,250.

PHINEAS TAYLOR BARNUM

1810–1891

P. T. Barnum was many things: a politician, a showman, a businessman, a philanthropist, an impresario, a curator, and—perhaps most famously—a humbug (a master at using hoaxes to create publicity). In his hands, animal remains became world wonders: an elephant skull became a Cyclops head; a goat skeleton and a narwhal tusk combined to form a unicorn; and perhaps most notoriously, a fish/mammal hybrid became a FeeJee mermaid. Barnum's greatest taxidermy feat was Jumbo, an African bush elephant that he purchased from the London Zoo in 1881. When the elephant died, Barnum called in Ward's Natural Science taxidermists Carl Akeley and William Critchley to create a mount, stretching the skin, per Barnum's directive, from 10.7 feet in life to 13.1 feet in death.

Barnum's American Museum in New York consisted of the nation's first aquarium, sideshows, pro-union exhibitions, salons dedicated to the Seven Wonders of the World, a rogue's gallery, wax figures, art, and all sorts of curiosities. The museum burned down in 1865, but what remains of his legacy can be seen at the Barnum Museum in Bridgeport, Connecticut.

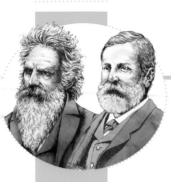

EADWEARD MUYBRIDGE & ÉTIENNE-JULES MAREY

1830–1904

Born one month and about five hundred miles apart, Eadweard Muybridge and Étienne-Jules Marey were pioneers of photography and motion pictures and forever changed the way humans observe the locomotion of animals. Both Muybridge and Marey developed technologies that utilized photographs to create the illusion of motion—Muybridge with the zoopraxiscope, where printed images on a rapidly rotating glass disc gave the impression of motion, and Marey with the chronophotographic gun, which took twelve photographs per second, capturing several phases of movement on a single negative.

Prior to the work of these two men in the late nineteenth century, artists and taxidermists required a keen eye or a creative mind to represent the flight of a bird or gallop of a horse (which may account for their many mistakes in the scale, motion, and character of animals). Although these motion studies provided unique and groundbreaking sources of observation for the naturalist, they also set the course for the declining relevance of museum dioramas. Taxidermy animals were once the only means for the public to learn about animals' lifestyles, but motion pictures soon proved to be more comprehensive teaching guides and gave the general public more exposure to animals in nature.

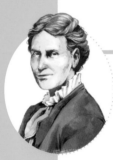

MARTHA ANN MAXWELL

1831–1881

Martha Ann Maxwell, dubbed the "Colorado Huntress" and a "Modern Diana," can be considered the patron saint of the Rogue Taxidermy movement for her perseverance in exploring science through art. A five-foot-tall naturalist and vegetarian, she battled prejudice throughout her life as a woman in a male-dominated field. She started several natural history collections; worked with the Smithsonian Institution to help identify the fauna of the Rocky Mountains; and had a subspecies of owl named after her, *Otus asio maxwelliae*.

In 1876, Maxwell was asked to represent Colorado at the Philadelphia Exposition. She created a complex habitat diorama (seemingly the first of its kind) that showed taxidermy animals, all of which she had hunted and mounted, as well as running water, some live prairie dogs, and a sign that read WOMAN'S WORK. It was one of the most popular exhibitions at the fair and was heavily covered in the press. Her work undoubtedly influenced both Carl Ethan Akeley and William Temple Hornaday as they developed their own taxidermy diorama styles. Only photographs of her collection have survived.

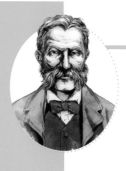

WALTER POTTER

1835–1918

Walter Potter left school at fourteen and began creating taxidermy pieces as a way to encourage visitors to his father's inn. It grew into Mr. Potter's Museum of Curiosities, devoted to anthropomorphic taxidermy tableaux. His most famous piece, *The Death and Burial of Poor Cock Robin,* based on the eighteenth-century English nursery rhyme, took him six years and depicts all of the animals in the rhyme in a graveyard, carrying Cock Robin to his final resting place.

While Potter was not the first or only taxidermist to turn kittens into brides, bunnies into disobedient students, and squirrels into poker players, he is definitely the most referenced. Every monocle-wearing, banjo-playing, mustache-sporting mouse owes a debt of whimsy to Potter. His museum was disbanded into private collections in 2003.

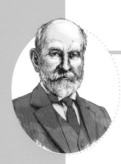

WILLIAM TEMPLE HORNADAY

1854–1937

William Temple Hornaday was not only an exceptional taxidermist—credited with winning the first taxidermy competition in 1881 with an orangutan battle called *A Fight in the Treetops,* as well as mounting the buffalo that was supposedly used by the U.S. Treasury as a model for the buffalo nickel—but he also profoundly changed what it meant to be a conservationist. Prior to Hornaday, conservation often meant simply killing and mounting animals before they became extinct. After taking a census of American bison through the American West and Canada and seeing the decimation of the population, Hornaday was moved to suggest intervention as a viable option to stave off extinction. He brought bison back to Washington to become part of a newly formed Department of Living Animals (later the National Zoo) and later founded the American Bison Society with Theodore Roosevelt. He also lobbied to create laws that would protect not just bison, but also seals, wild birds, and other fauna.

As the chief taxidermist at the United States Natural History Museum (which later became the Smithsonian), and the founder and director of the New York Zoological Park (now the Bronx Zoo), he established the idea that conservation and animal stewardship are integral aspects of the taxidermy discipline. Hornaday's bison mounts are on display at the Museum of the Northern Great Plains in Fort Benton, Montana.

CARL ETHAN AKELEY

1864–1926

Carl Akeley remains the most important figure in American taxidermy. He is often referred to as the father of modern taxidermy, because of both the advances he made in the artistic approach to taxidermy and his larger-than-life persona.

Dissatisfied with the quality of the taxidermy of his day, Akeley approached the process like a sculptor and strived to create greater anatomical correctness and artistry in the medium. There is no doubt that his example helped to transform the field. The Akeley Hall of African Mammals in the American Museum of Natural History in New York is one of his greatest achievements, although it was finished after his death. Akeley's work can also be seen at the Milwaukee Public Museum, the Field Museum of Natural History, Chicago, and the Brooklyn Museum.

But it is not merely his technical skill that makes Akeley a legend. He helped prepare the mount of P. T. Barnum's Jumbo, once rode an animal carcass as a raft across a crocodile-infested river, went on safari with presidents and kings, survived being stomped by an elephant, and once killed a leopard by punching it to death *from the inside* after it latched onto his hand. In his lifetime, Akeley killed tens of thousands of animals in the name of conservation (the idea being to collect examples of the creatures before they went extinct). But near the end of his life, after a run-in with a baby mountain gorilla he named Carl Junior, Akeley changed his conservation methods and encouraged the creation of the first national park in Africa. Akeley died while on safari on Mount Mikeno, not far from the spot depicted in his Mountain Gorilla diorama at the American Museum of Natural History.

DELIA JULIA AKELEY

1875–1970

Delia Julia Akeley (known as Mickie) was the first wife of Carl Akeley and made significant contributions to his work. She met Akeley while he was working at the Milwaukee Public Museum and quickly became his taxidermy assistant. She accompanied Akeley on two of his most important expeditions to Africa, collecting plants and specimens that would later be re-created and serve as resource materials for the organic nature in the dioramas at both the American Museum of Natural History and the Field Museum. Mickie even shot and killed one of the elephants that is mounted in the African Hall of the American Museum of Natural History.

Mickie and Carl were divorced in 1924. She continued to travel to Africa, developing an interest in ethnographies and the study of people. She remains a symbol of persistence, exploration, and adventure for young women in the field of taxidermy.

FRANCIS LEE JAQUES

1887–1969

Francis Lee Jaques was an illustrator, painter, and naturalist who advanced the art of dioramas through his seamless merging of the three-dimensional foreground with a spacious, expanding flat background. He spent more than two decades at the American Museum of Natural History designing diorama halls and painting wildlife scenes and dioramas. Stubbornness (or artistic commitment) played a part in social conflicts that limited his career, and while his influence is evident in the Hall of Birds, he painted only one mammal diorama, the Musk Ox. Examples of his diorama painting can be seen at the Bell Museum, the American Museum of Natural History, and the Peabody Museum.

SIR ALFRED JOSEPH HITCHCOCK

1899–1980

Sir Alfred Hitchcock was a masterly storyteller and prolific filmmaker. His fifty-third film, *Psycho,* is significant for many reasons, not the least of which is that it may have had the biggest negative impact on the field of taxidermy in popular culture to date. In making his disassociated, homicidal main character a taxidermist as a means of foreshadowing the suspenseful ending, Hitchcock recontextualized taxidermy as a physical manifestation of male violence and equated the skill with murderous desires. *Psycho* was one of the most successful films of Hitchcock's career, and the character of Norman Bates has haunted the field of taxidermy ever since.

JORGE LUIS BORGES

1899–1986

Jorge Luis Borges was a poet and a writer whose work merged fantasy, philosophy, and a scholar's deep knowledge of literature. His 1957 work *Manual de Zoología Fantástica* (released in English translation in 1969 as *The Book of Imaginary Beasts*) was a "handbook of the strange creatures conceived through time and space by the human imagination." With a challenging mix of literary fact and fiction, *The Book of Imaginary Beasts* encourages the reader to believe in fantasy—or at least question reality—in the face of modernity and science. Borges's pseudoeducational approach to natural history influenced much of the work of contemporary taxidermy artists, where a foundation of scientific research inspires fantastical creations.

MÉRET OPPENHEIM

1913–1985

At just twenty-three, Méret Oppenheim created one of the most rec-ognizable pieces of Surrealist artwork of all time: a piece called *Le Déjuener en Fourrure* or *Breakfast in Fur*. The work (a fur-lined teacup) was inspired by a conversation between Oppenheim and Picasso about a fur-lined bracelet, which prompted Oppenheim to remark that any-thing could be covered in fur. The founder of Surrealism, André Breton, wrote that the piece was a triumph in the Surrealist's quest "to hound the great beast of function." Oppenheim was the sole female Surreal-ist and is an inspiration to Rogue Taxidermists, who often are women working within a traditionally male-dominated medium. *Breakfast in Fur* has been in the collection at the Museum of Modern Art in New York since 1936, and Oppenheim's other work can be seen at museums all over the world.

THE
ARTISTS

This book gave me an extraordinary opportunity to travel the world to meet the most influential artists working with taxidermy materials and in bio art today. While I've gotten to know many of the artists online, thanks to the Internet and social media, there is nothing quite like visiting them in person, seeing where they live and make their art, and talking about their works in process.

From caves in Norway to back galleries in Los Angeles, these artists explore the conceptual spaces where animals and humans intersect. Their backgrounds vary widely: Three are traditionally trained taxidermists, many were formally trained in art schools, and others are completely self-taught. What they all have in common is that their work extends far beyond traditional taxidermy: Five of the artists profiled here create some work using only bones, two employ wet preservation, two practice mummification, and three do not use animal parts in their work at all.

Despite the remarkable diversity of their artistic practices, these artists draw on similar themes in their work. Claire Morgan and Mark Dion use installations to transform space, both in the gallery and beyond, while Lisa Black and James Prosek touch on facets of science, the former futuristic and the latter naturalistic. Animal stewardship is a strong thread that runs through the environmentally focused work of Rod McRae, Julia deVille, and Sarina Brewer. Iris Scheiferstein, Katie Innamorato, and Nate Hill explore means of mending the trauma of roadkill. Peter Gronquist and Scott Bibus all show animals in the context of pop culture, while the works of Jessica Joslin and Les Deux Garçons allude to times past. Kate Clark and Polly Morgan employ traditional sculptural techniques to illustrate the animal form. And fables, storytelling, and narrative are principal focuses in the works by Idiots, Tessa Farmer, Mirmy Winn, Liz McGrath, and myself. It should be noted that these artists work only with parts from animals that died accidentally or from natural causes; in their view, the art of taxidermy is never a rationale for killing.

I am excited to share this incredible work with you. Join me as we explore the outrageous and inspiring world of taxidermy art.

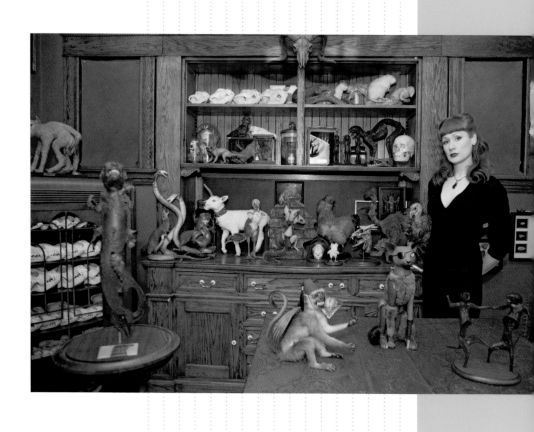

SARINA BREWER

Sarina Brewer is the grande dame of the Rogue Taxidermy movement, a leader both ethically and aesthetically and a founding member of MART. Her artwork is based in the worlds of oddities and mythology, and she conjures up figures that may or may not exist in nature. She is best known for her beautiful chimeras, imaginary animals made up of incongruous parts. Chimeras take their name from a fire-breathing beast in Greek mythology that had the heads of a lion, a goat, and a snake. Such creatures aren't entirely fictional: animals born with two or more heads, a condition called polycephaly, have long been popular collectors' items. In modern day parlance, the term *Chimera* has also expanded to mean an organism that has been joined with another organism via genetic engineering or natural mutation. Sarina's work deftly orbits the many implications of the term.

Like Sarina's flying monkey holding a martini glass, her chimeras have a tongue-in-cheek quality and a sculptural bearing that separate them from the Rogue Taxidermy of yesteryear (such as the jackalope). Evident in all is the hand of an artist; many pieces are embellished with colorful pigments, and all bear painstaking workmanship. It is exceedingly difficult to graft together pieces of different animals in such a naturalistic way because it requires a strong eye for anatomy and a dexterity with the profound limitations of fur and flesh.

Sarina uses only ethically procured animals, such as roadkill, livestock remnants, animals that died of natural causes, and destroyed nuisance animals that are donated to her. Out of respect for the animal being used, she has developed an artistic process that eliminates waste. In addition to practicing taxidermy, which uses only skin for the mount, Sarina developed a technique she calls esodermy, preserving the muscle and bones to create a mummified, skinless sculpture. In this way, no part of the animal is discarded needlessly.

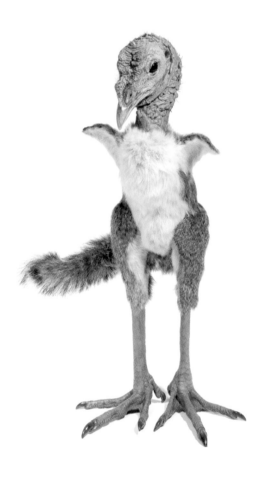

Turkelaeopteryx

OPPOSITE: *Mother's Little Helper Monkey*

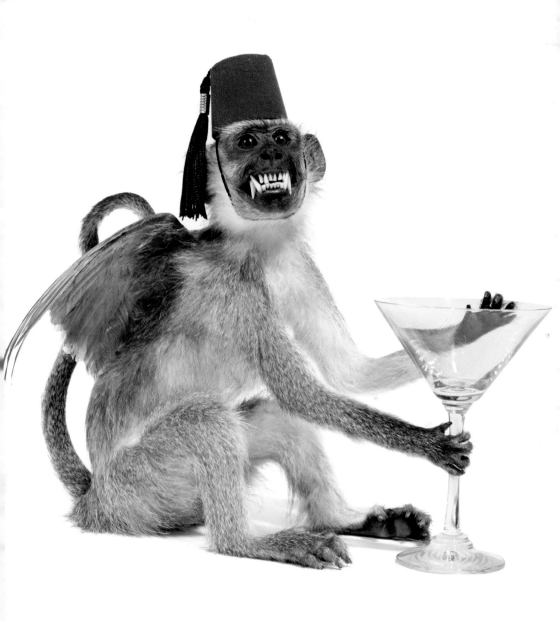

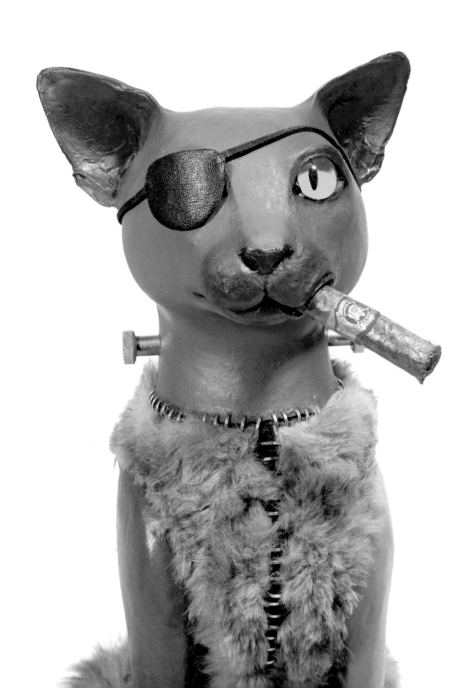

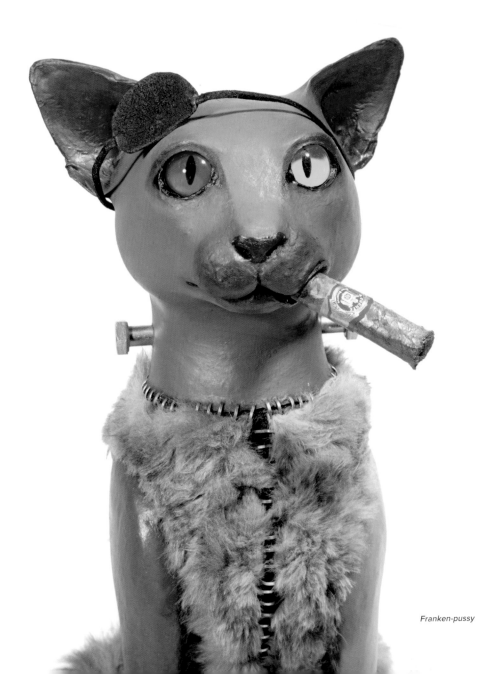

Franken-pussy

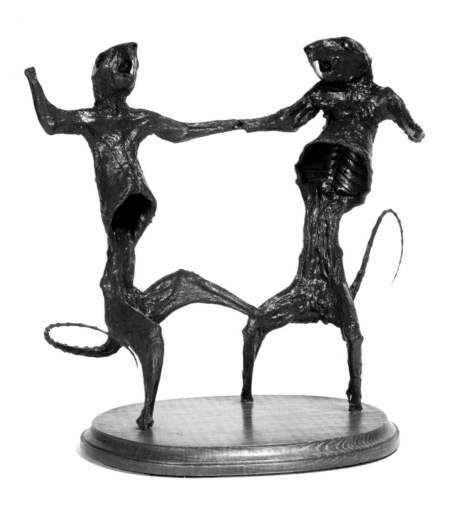

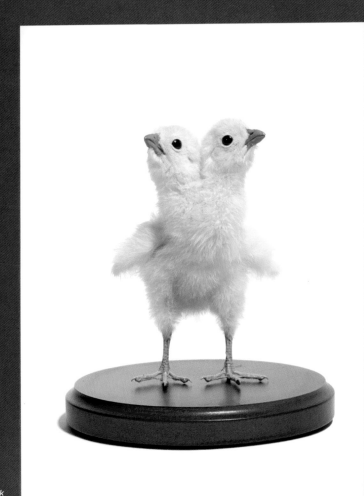

Two-headed Chick

OPPOSITE: *Jitterbug*

SCOTT BIBUS

Blood and guts are discouraged in traditional taxidermy. Even scavengers like vultures are conspicuously bloodless in museum dioramas. While in taxidermy school Scott Bibus decided to challenge this tradition and showcase the gory side of death. The first piece he produced was a small diorama of a beaver eating a human thumb. Although it was received with more confusion than disgust, his work has continued along this bent. Scott brings a campy, horror-film aesthetic to taxidermy by showing gruesome scenes of animals eating human parts, mutations, and zombie animals in midscream. Like the cinematic genre that inspires him, Scott's work hints at transgression, in this case screwing with animal imagery.

One of Scott's main influences is La Specola, now part of Museo di Storia Naturale di Firenze, in Italy, which features a collection of beautiful yet gruesome wax anatomy sculptures. Like the flayed specimen in La Specola, Scott peels back the skin of his mounts to reveal the horrors of nature, often to a theatrical extreme. There's a gleeful, mischievous tone to many of his works, such as a squirrel disemboweling itself.

In addition to creating art, Scott has led gastronomy-influenced events called Masterclass/Gamefeeds, where the animal being prepared for taxidermy is also served as food. (Rabbit, squirrel, and chicken are the usual subjects.) Scott is a founding member of MART, and his use of twisted humor to demystify the process of taxidermy, as well as his appetite for horror flicks, have made him an ambassador to the next generation of Rogue Taxidermists—even as he embarks on a new career: making fright props for haunted attractions.

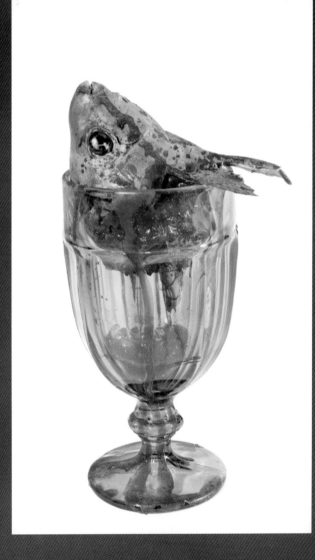

Parrotfish Cocktail

OPPOSITE: *Beaver Eating Human Thumb*

Snapping Turtle Eating Human Eyeball

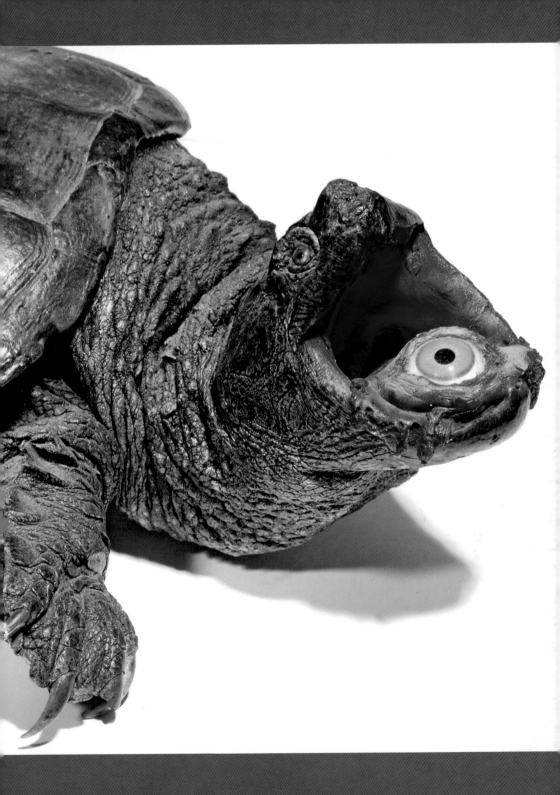

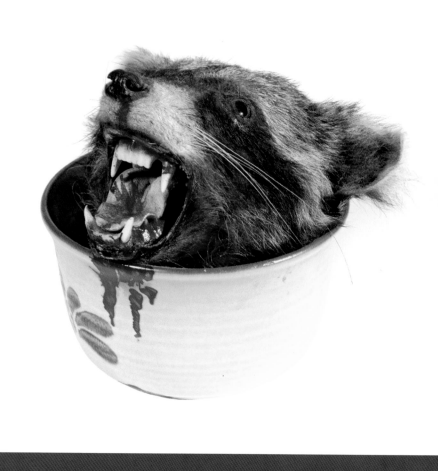

Raccoon Head in Cereal Bowl

OPPOSITE: *Swan Song*

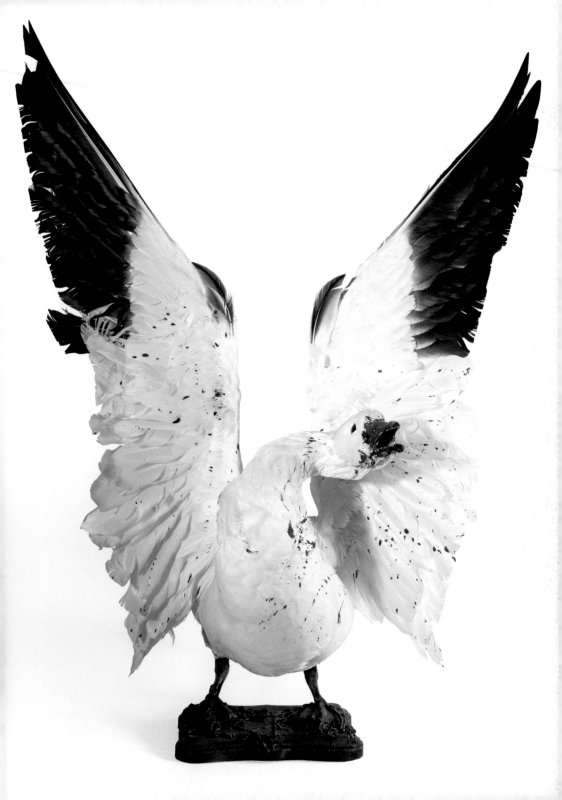

ELIZABETH McGRATH

LOS ANGELES, CALIFORNIA

Liz McGrath creates a creepy universe of wounded animals that are doing the best they can in a world of adversity. Their large eyes often seem to be on the verge of welling up with tears, but they hold strong—like tough street urchins from the animal kingdom. Liz's work, though not deliberately autobiographical, nonetheless draws from her own troubled youth, one which involved excessive teenage rebellion (complete with a triple mohawk), a stint at a fundamentalist Baptist correctional institution, and hard-partying days as the leader of a punk-rock band and downtown denizen. Her creatures have a similarly antiauthoritarian attitude.

Even though Liz does not work with actual animal remains, her self-taught style utilizes taxidermy-related materials (manikin forms, glass eyes, clay) and devices like wall-mounted heads and dioramas. But here the dioramas are embedded in the animal's body, and wall mounts are typically tasked with carrying some Sisyphean load like a heavy ship—a nod to the weighty baggage they're saddled with.

Indeed, Liz's characters wear their baggage like a badge of honor—they *own* it. They have dark backstories that leave behind scars or inspire really good nicknames. (Liz has one herself: the better part of L.A. knows her as "Bloodbath" McGrath.) They've gone through battle and wear their adversity like a drag performance: Some works incorporate gold leaf and Swarovski crystals, others wear patches, and many boast elaborate ink by her artist husband, Morgan Slade. Liz's gift is turning tragedy into offbeat beauty, and her darkly whimsical style invokes hope in even the most forsaking situations.

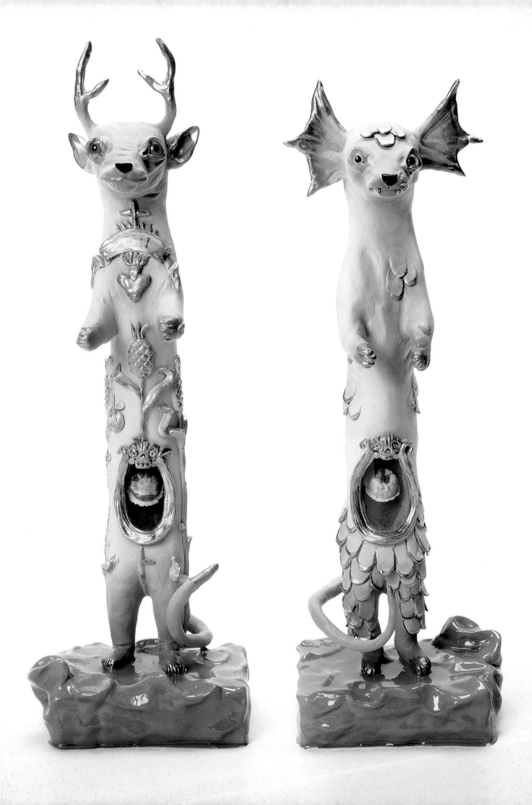

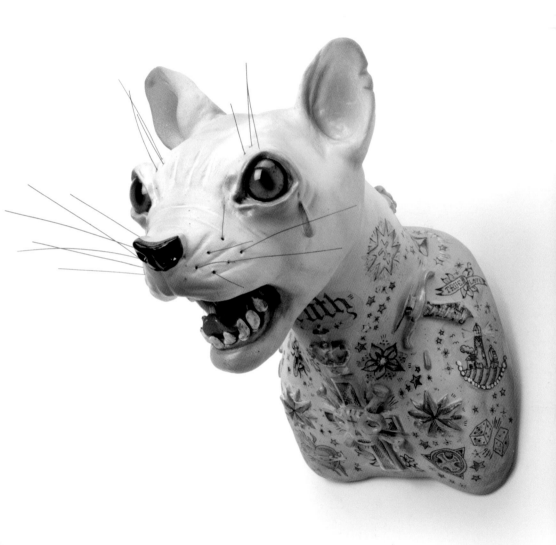

Truth Lights Cougar

OPPOSITE: *The Royal Weasels*

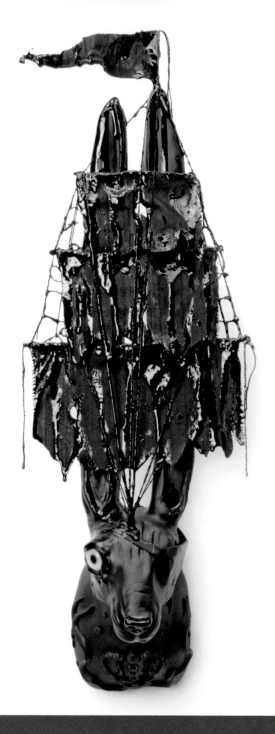

We Are All Ships in the Night

OPPOSITE: *Deer House*

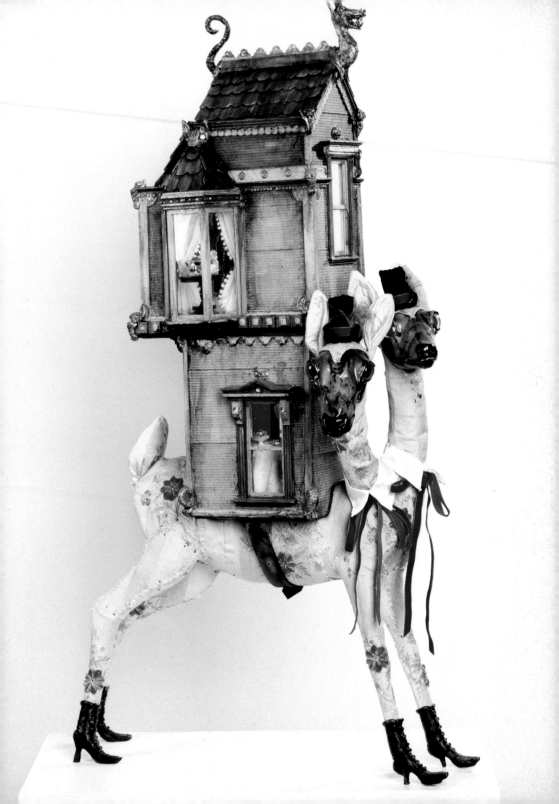

LES DEUX GARÇONS

Les Deux Garçons are Michel Vanderheijden van Tinteren and Roel Moonen. The two sought each other out after mutual acquaintances at university noted their shared fashion sense and taste for the absurd, and they formed an art collective to explore their common interests and surreal sensibility.

The duo is heavily influenced by eighteenth-century French decorative arts and they incorporate elements of craftsmanship like bows, inlays, and passementerie into their work. Birds emerge from shattered tea sets, animals are bound together by ribbons to form quirky Siamese twins. Their taxidermy-based pieces are often shown alongside other objects and ephemera collected from flea markets and antiques dealers throughout Europe. The works are typically presented in bell jars and glass vitrines, like hermetic little worlds that need to be protected. Using these elements of display and arrangement, Michel and Roel take on the role of curators.

The detail in their pieces is carefully considered and exudes the air of another time, an attitude that unifies their diverse body of work, ranging from taxidermy mounts with stuffed-animal heads to stage sets and costume designs for the theater. Their period aesthetic is especially evident in their delicate ceramic figurines topped with bird or small mammal heads, which combine to create true objects of luxury and indulgence.

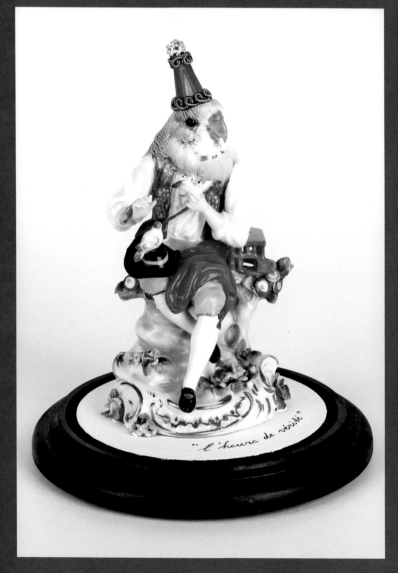

"l'heure de vérité"

L'Heure de Vérité
OPPOSITE: *La Fragilité*

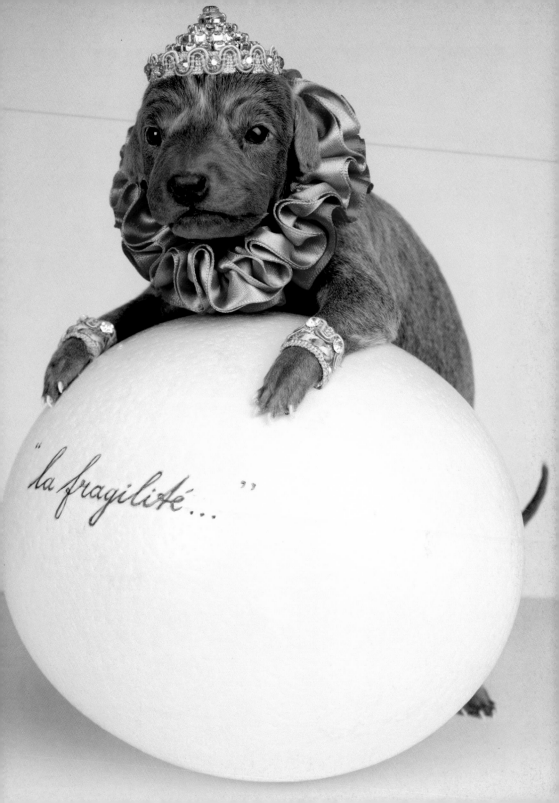

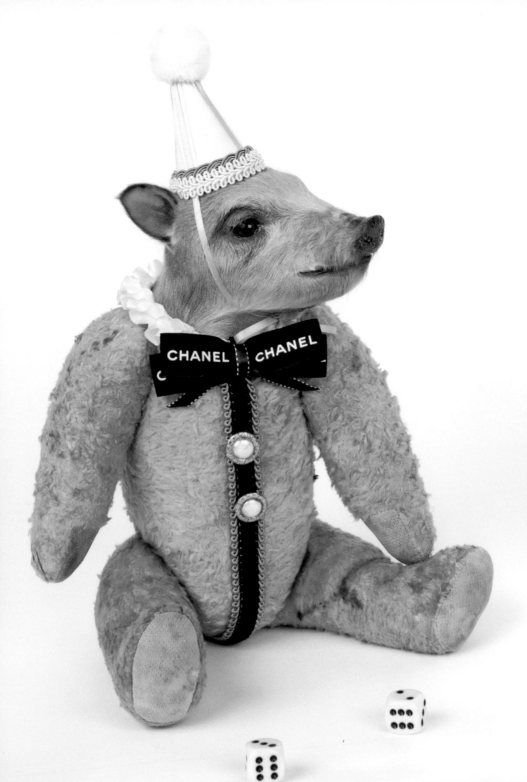

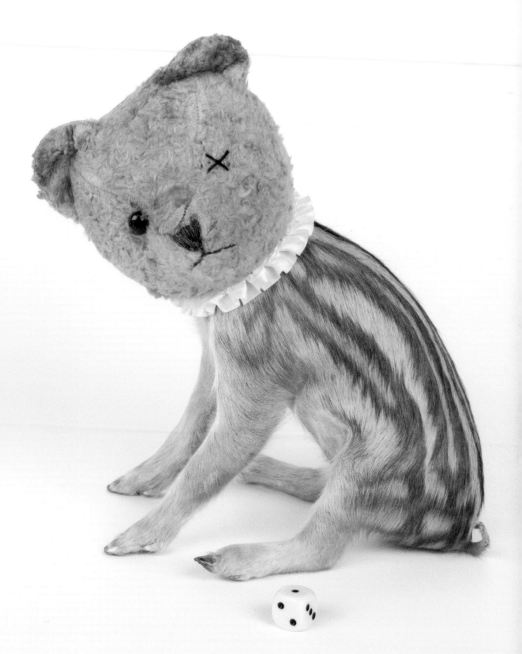

Le Jeu

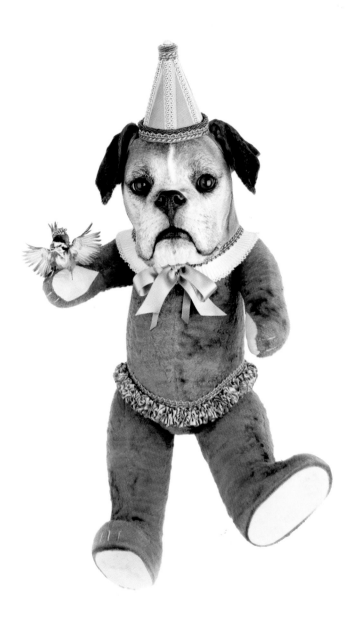

Saltimbanque

OPPOSITE: *L'Adieu Impossible*

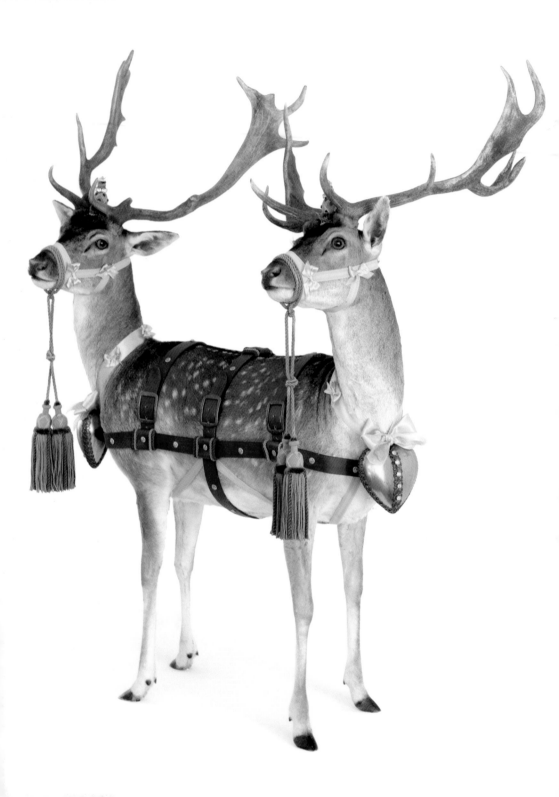

KATIE INNAMORATO

NEW PALTZ, NEW YORK

Katie Innamorato's work often starts with casualties of car collisions. Her use of roadkill inevitably demands a high degree of improvisation and experimentation, since the hides are generally quite damaged. Katie has developed an arsenal of creative tricks to efface their rough condition and is constantly experimenting with new ways to tweak traditional taxidermy by incorporating sound, plant life, or foreign objects. Skin missing because of trauma or rot is often patched with moss, giving the creature the look of an elder spirit—part earth, part animal. Sometimes she inserts tubes through the cavity of the mount to house LED lights or sound systems, introducing a functional element to the mount while strategically filling damage in the hides. She even casts death masks of animals that are too far gone to rescue.

Foxes make frequent appearances in her work. They are plentiful as roadkill where Katie lives, and she harbors a particular affection for red foxes after rescuing one from a questionable owner. Working with both living and dead foxes reflects Katie's immersive practice. She continues to train with a traditional taxidermist while exploring the medium through hands-on stewardship, taxidermy competitions, gallery shows, and teaching workshops, the combined influence of which propels her work ever closer to the realm of conceptual art.

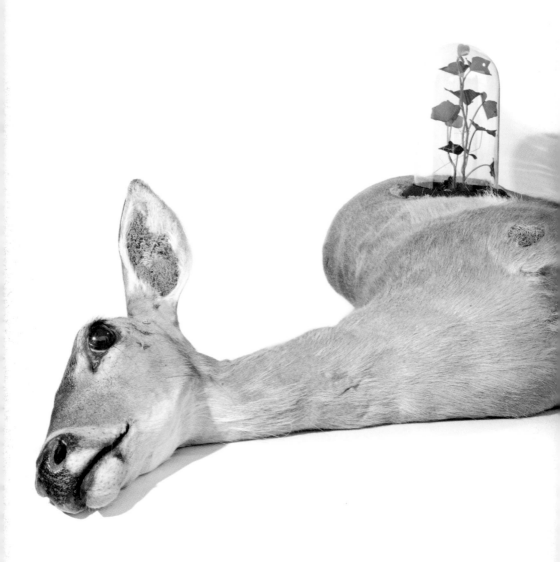

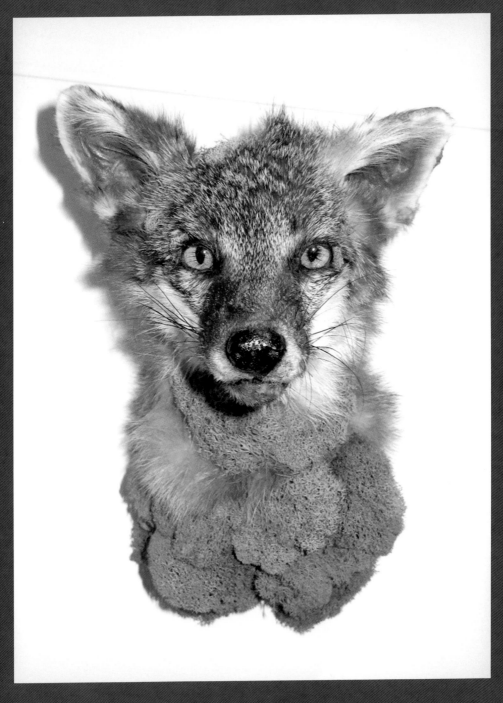

Moss Fox

OPPOSITE: *Cannulated Doe Terrarium*

Cannulated Coyote Terrarium

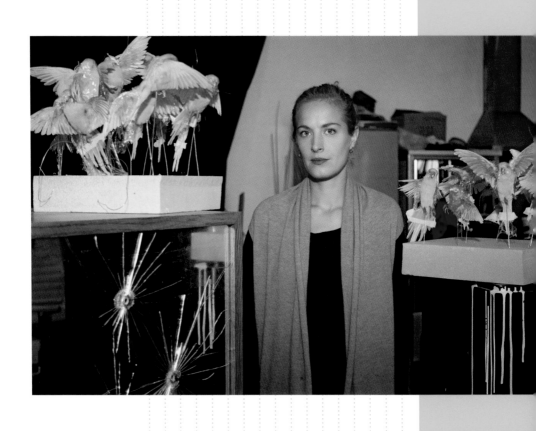

POLLY
MORGAN

LONDON, UNITED KINGDOM

Polly Morgan didn't set out to become an artist—or a taxidermist for that matter. She was managing a bar and living in London's artsy Shoreditch neighborhood when she began scouring the Internet for a mount to decorate her flat. She wanted a piece that looked dead, not artificially alive, and when her search turned up dry, she tried her hand at realizing her vision. Not one to do things halfway, Polly trained under traditional taxidermist George C. Jamieson and proved a quick study. She began producing work and secured gallery representation almost immediately. Her debut show sold out; Damien Hirst and Banksy were among her first supporters.

Her early work often showed realistic animals in poses that suggested their recent death: a lovebird looking in a mirror, squirrels curled up limp in a martini glass. Polly's sensibility has since evolved to a more magical realist depiction of mortality. Mushrooms grow from the wound of a gutted pig. An octopus's tentacles pierce the carcass of a fox reaching for birds in flight. Piglets suckle a dripping log for sustenance.

Her work often toys with what's called the "uncanny valley," an art-world term borrowed from robotics to describe our love/hate relationship with the artificial. Scientific studies have shown that the more human that robots look, the more we like them, but only to a point: We are repulsed by anything just shy of complete verisimilitude. Polly explores this gray area where familiar animal representation merges with the unknown, and where reality blends with fantasy.

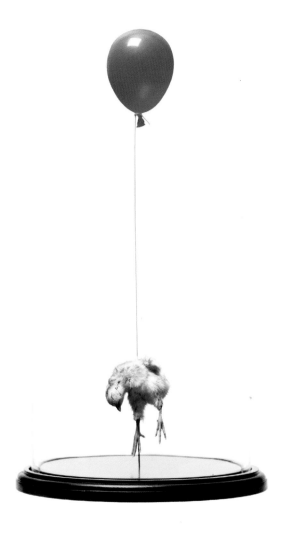

Still Birth (Red)
OPPOSITE, LEFT: *Still Birth (Green)*
OPPOSITE, RIGHT: *Still Birth (Blue)*

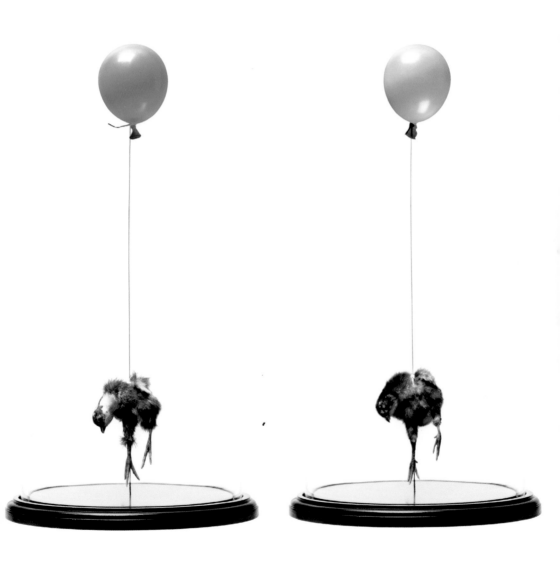

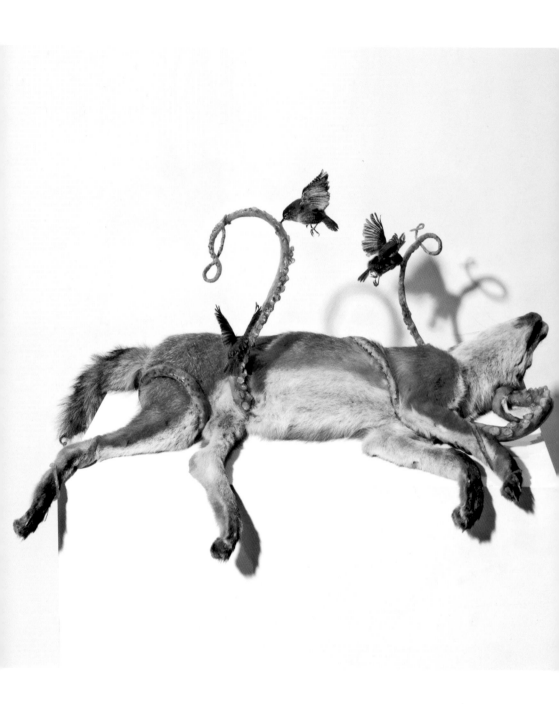

ABOVE and OPPOSITE: *Harbour*

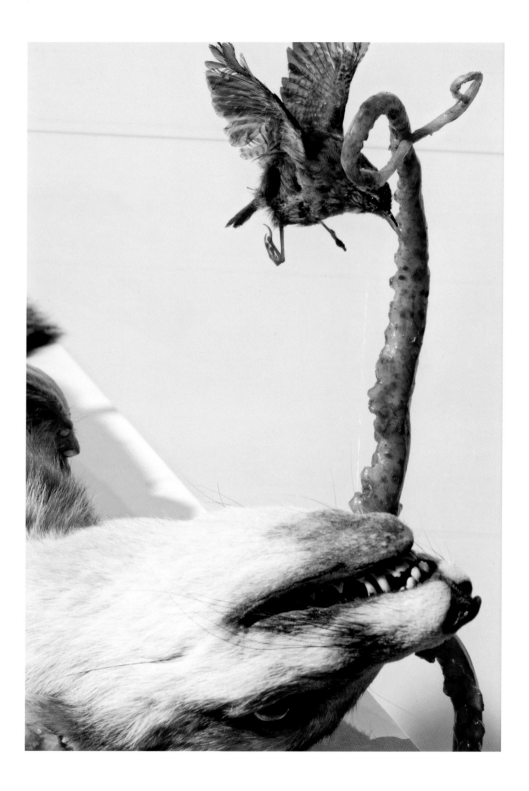

One Can Only Hope
OPPOSITE: *Passing Clouds*

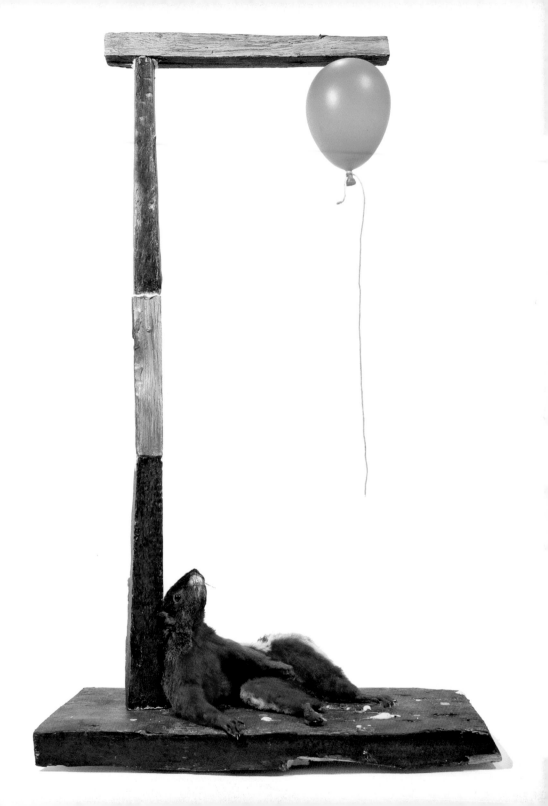

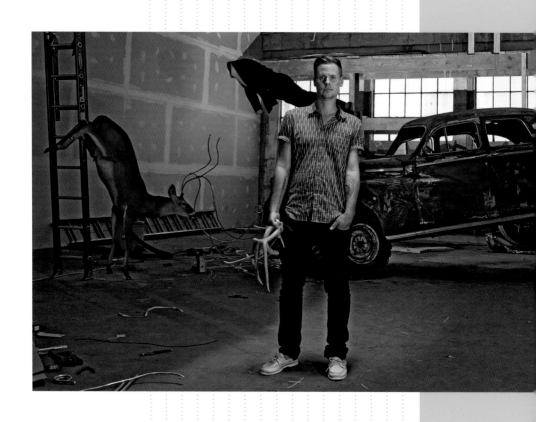

PETER GRONQUIST

Peter Gronquist is heavily influenced by pop culture. How else to explain a deer mount wearing a giant, gold Gucci logo in place of antlers? Or a water buffalo whose horns morph into golden machine guns? The artist's edgy mash-ups of natural history and ghetto fabulousness co-opt the visual language of hip-hop, music videos, online gaming, and comic books. But high-art references are equally evident: a painter by trade, Peter has a masterly grasp of symmetry, composition, and pictorial space—making his work all the more powerful.

Peter creates his pieces by repurposing existing taxidermy mounts, replacing their antlers and horns with his customized weaponry and bling. In doing so, he gives the animal a new identity and a new societal status: The hunted becomes the hunter—in the guise of a gangsta sporting Chanel or Louis Vuitton. The pieces set up double entendres, calling to mind words like *sport, trophy,* and *prize* that are used in the context of both game-hunting and luxury-good buying—flip sides of the same consumerist coin. Infused with cheeky humor and social criticism, his work is a lacerating riff on consumer culture and its victims, whether wildlife or the disenfranchised—both of whom can "buy" into a higher social stratum through luxury goods. His animal characters have become complicit in the covetous impulse that robbed them of their lives—which makes viewers wonder whether we are complicit too. Nor does the artist exonerate himself: A recent self-portrait depicts Peter being thrown from a 1947 Chrysler Traveller rammed by a deer with gilded antlers.

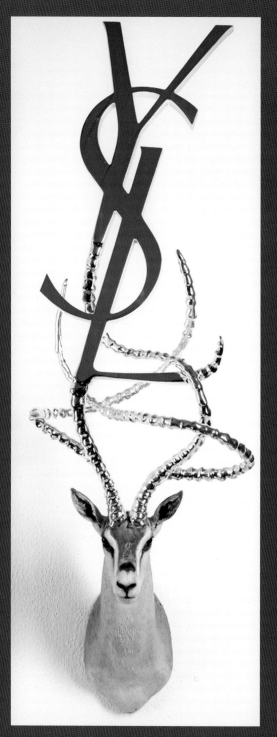

Genetic Branding (YSL)
OPPOSITE, ABOVE: *Untitled*
OPPOSITE, BELOW: *Untitled*

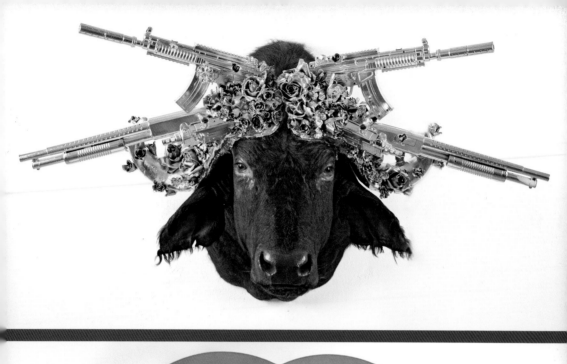

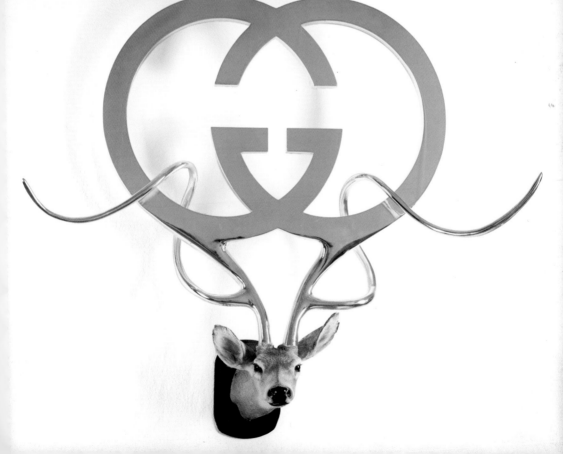

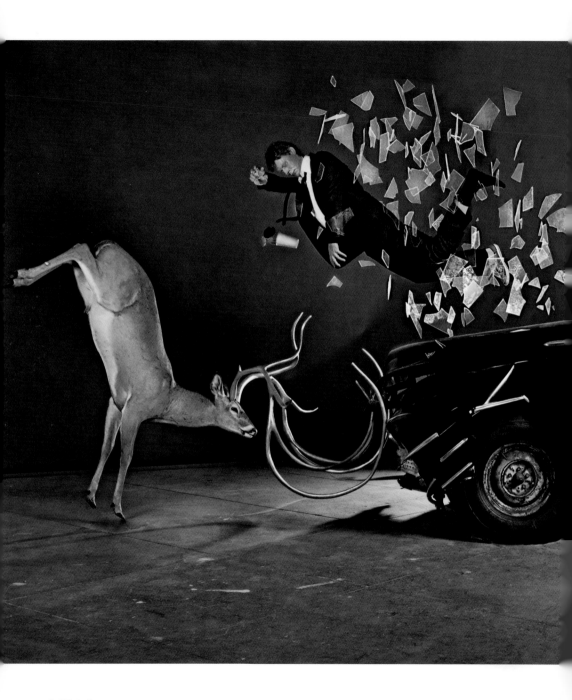

Self-Portrait

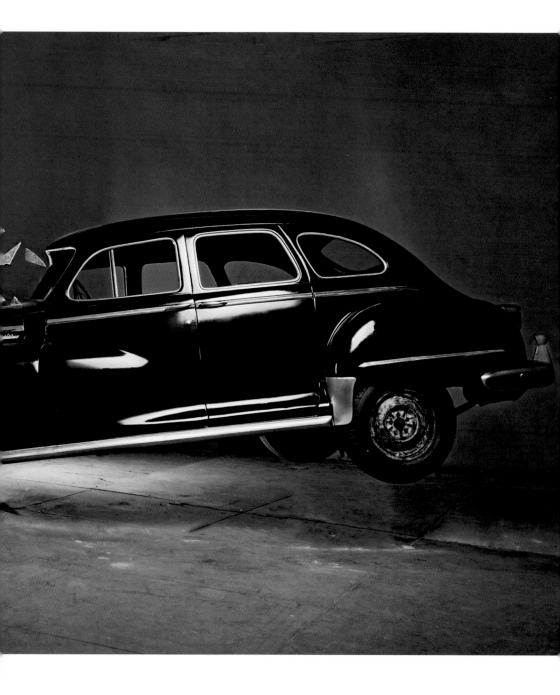

JESSICA JOSLIN

CHICAGO, ILLINOIS

Jessica Joslin jokes that she is a rogue osteologist—or "bone scientist," to the uninformed. She combines animal bones with fine metalwork to create skeletal characters with striking individuality: a be-hatted monkey balancing on a ball, a dog begging hungrily for a treat. Jessica's immediately identifiable style is equal parts ornament and oddity, laced with an aura of nostalgia. Her work synthesizes disparate influences ranging from early zoological collections and circus imagery to the industrial innovations of the 1851 Great Exhibition. They confidently meld curiosity and luxury in the style of the eighteenth-century menageries that inspire her.

The daughter of a fabricator, Jessica is a tinkerer herself, bringing a Mr. Fix-It quality to the construction of each piece. She revels in the process of fitting together bits of metal and shiny brass in a manner that's structurally sturdy yet delicate-looking. Giving these mechanical animals a natural pose with proper articulation demands attention to detail as well as observation and skill—especially since her animals have no skin to hide behind. Jessica gives her characters physical and emotional naturalism, animating them with traces of humor and compassion, to the degree that the viewer often forgets the work has anything to do with death.

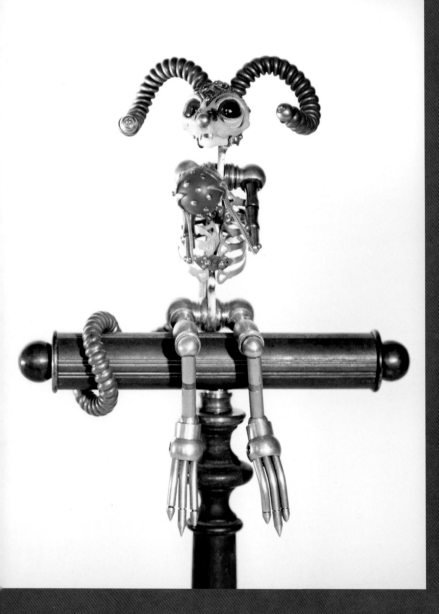

Otto
OPPOSITE: *Wolfgang*

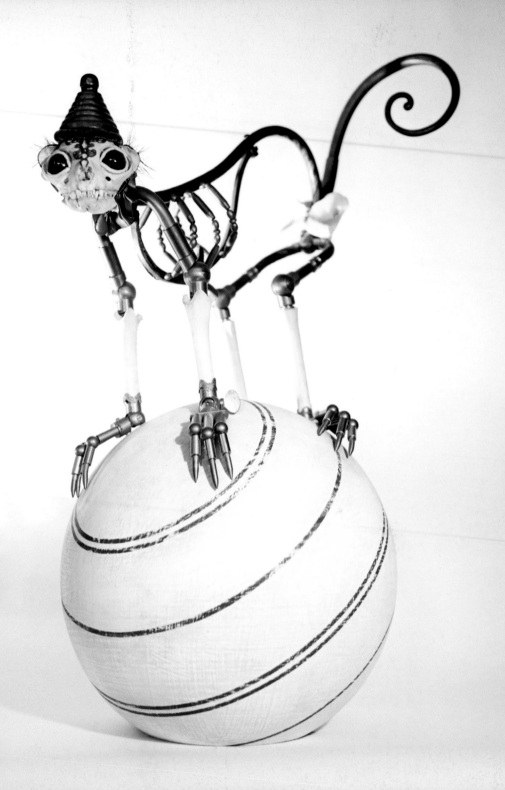

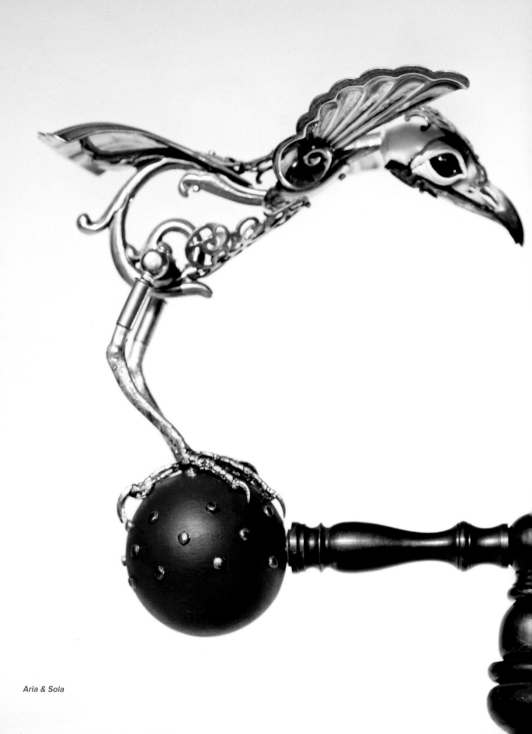

Aria & Sola

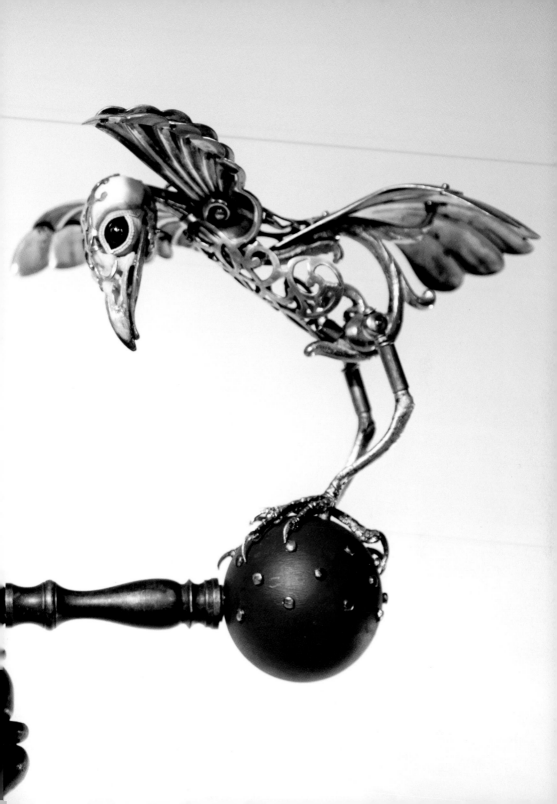

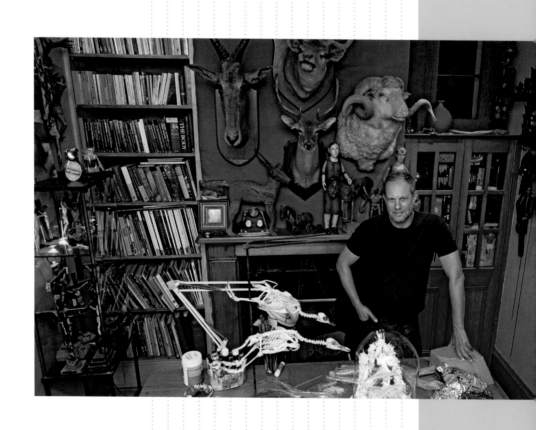

ROD McRAE

SYDNEY, AUSTRALIA

Rod McRae creates evocative installations that have the feel of a storybook come alive. This is not a coincidence. In another life, Rod was a successful children's book illustrator, publishing more than fifty books. Courtesy of that background, he has a special knack for distilling weighty concepts into easily digestible imagery. The often humorous scenes he creates lead viewers through narratives that set up a dissonance between the animals' true nature and our simplified idea of what they symbolize.

Using mostly traditional mounted taxidermy and big game like zebras and lions, he sets up fablelike scenarios that pull animals out of their natural habitats. The scenes have many layers of meaning, offering viewers numerous ways to understand and relate to the work. A juvenile polar bear teetering on the edge of a partially submerged refrigerator could be interpreted in a number of ways, all equally valid: nature wobbling on the brink of extinction; the fridge replacing the iceberg without providing the bear any benefits, such as food or ice; the heartbreaking reality of the extinction threat to the polar bear due to global warming.

All of Rod's work is in the service of environmentalism. Much like early American conservationists, he believes that showing the public an animal "in its most authentic form" is the most effective way to motivate people to save an animal species and make them reconsider their relationship with and impact on the environment. The more we identify with nature, the stronger our incentive is to protect it.

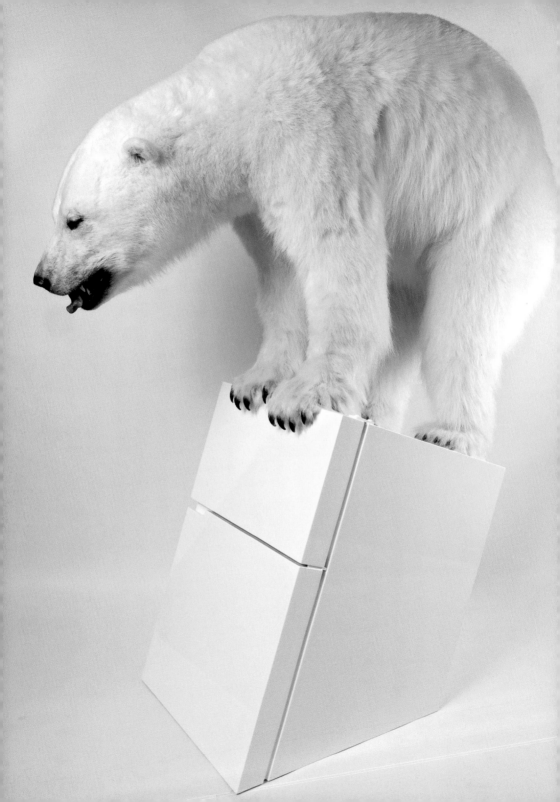

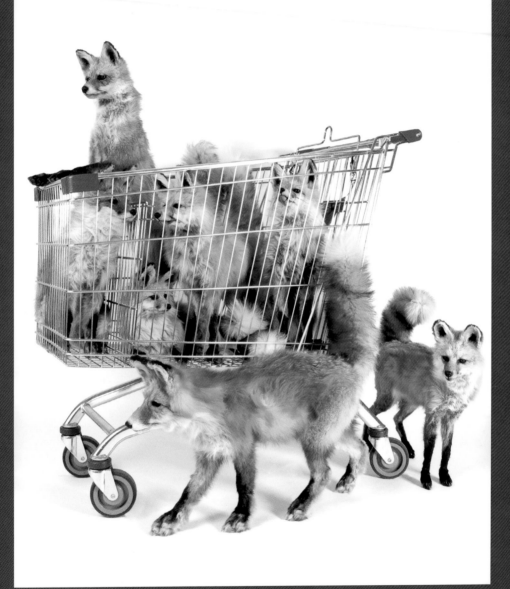

Operation Foxtrot

OPPOSITE: *Crying Out Loud in the Age of Stupid*

Are You My Mother?

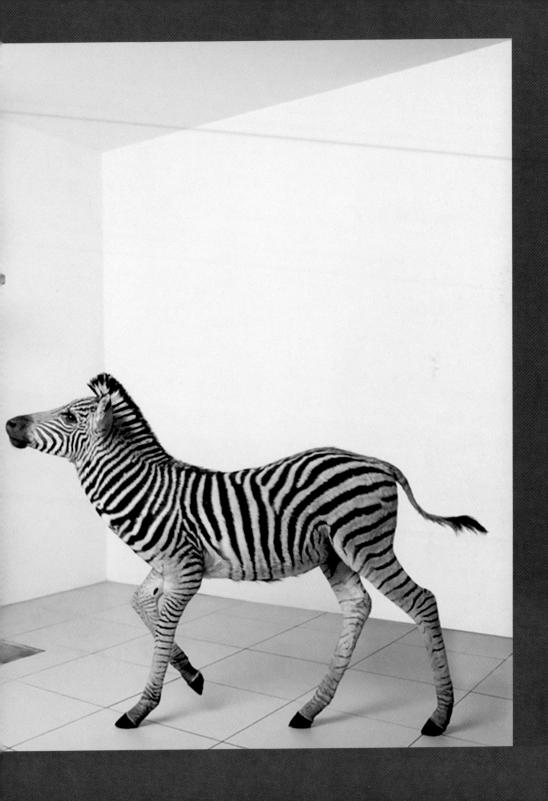

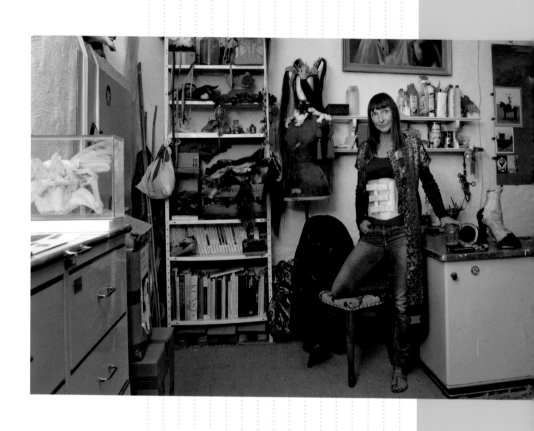

IRIS SCHIEFERSTEIN

BERLIN, GERMANY

Iris Schieferstein is perpetually moving and matter-of-fact. Only one month after serious back surgery, the only evidence of setback is the Velcro cast she wears around her torso. She makes no effort to hide this or her artistic intention to give a new face to death using various materials and animal imagery—whether making sculptures out of cattle bones or taking theatrical self-portraits with her horse. Her disturbing, confrontational stance encourages the viewer to reconsider his or her beliefs about animal relations.

The outrage sparked by her art is integral to its conception, and she relishes exposing societal contradictions, hypocrisies, and misguided belief systems. Iris is perhaps best known for merging fashion and death in a series of high-heeled shoes made from cow and horse hoofs, making the point that the material is no different from shoe leather. In another body of work, Iris used roadkill to create wet preservations, which she stitched together to spell out words like *NICE* and *ELVIS*. That series incurred the wrath of the government (using roadkill is illegal in Germany), not to mention her critics. She discovered that using dead farm animals in her work drew fewer complaints than dead domesticated animals—hypocritical indeed.

Orbiting her work aggressively are Iris's feelings of being persecuted: her trouble with the German government over the legality of her work, hate mail she has received "in every language," the challenges of single motherhood and being a female artist in a "man's world." Iris embraces these difficulties as crosses to bear in pursuit of a higher truth—and as what places her in the context of outsider artists and innovators who disrupt the status quo to shift paradigms.

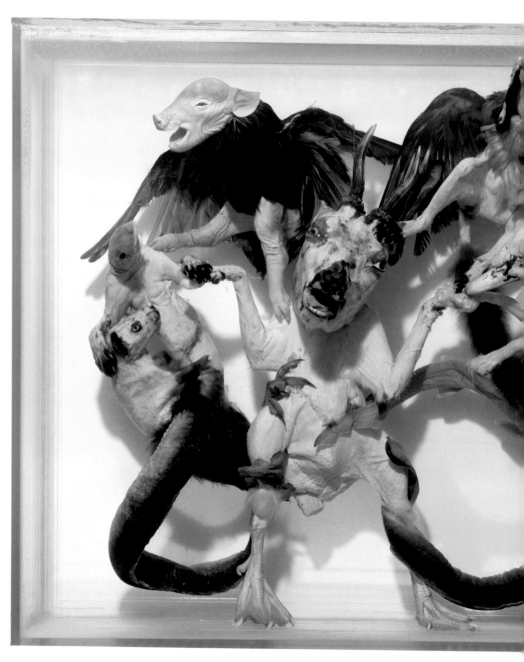

O.T. (Untitled)

OPPOSITE: *Vegas Girl*

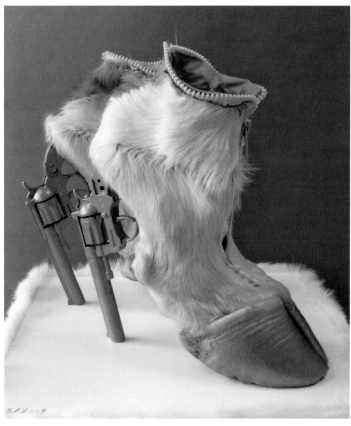

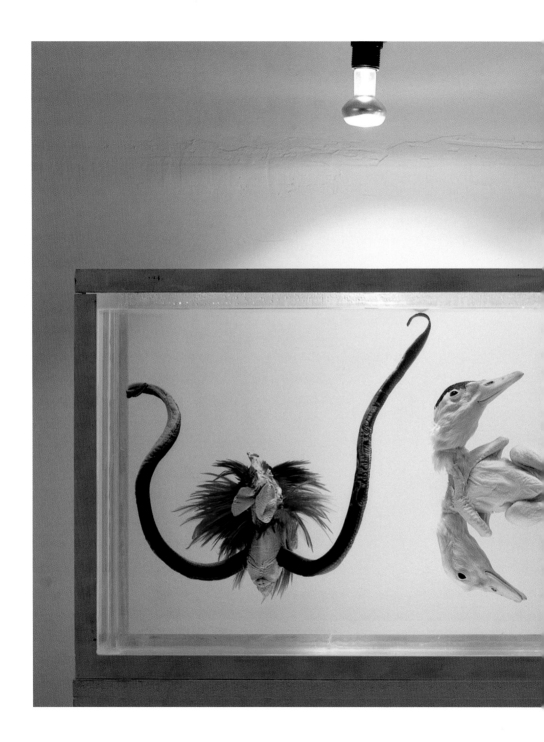

From *Davon geht die Welt nicht unter*

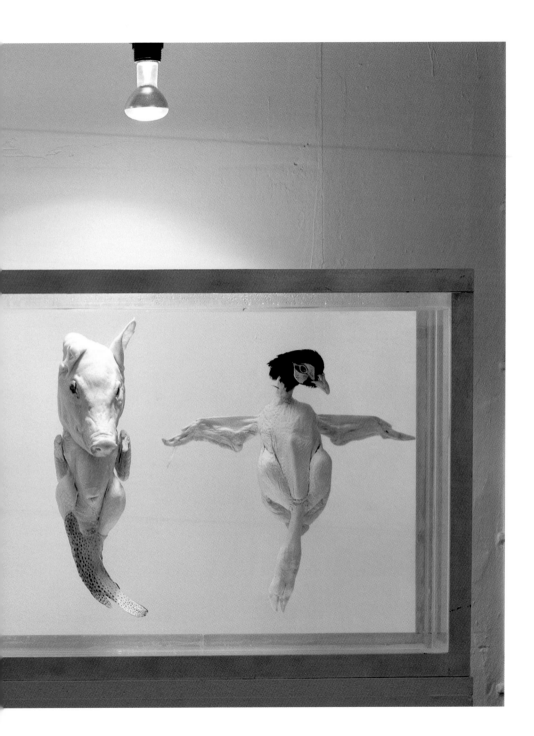

CLAIRE
MORGAN

LONDON, UNITED KINGDOM

Claire Morgan's work is about freezing time and space. The artist creates large-scale installations by mounting organic matter on a gridlike matrix of invisible filaments, creating the impression that the fragile materials (dandelion seeds, leaves, dead flies) are suspended in midair. Caught within each piece is a taxidermy mount: a bird with wings outstretched, a skulking fox. Literally and figuratively arresting, the installations are like 3-D versions of stop-motion photography.

Producing the work is an exercise in patience, one that begins by collecting and meticulously cataloging raw materials in her East London studio. Each piece is born from a perspectival sketch of the envisioned installation; from there, Claire works backward, diagramming how she'll structure and assemble the elements. The armatures often require thousands of strings, to which the materials are hand-tied. The taxidermy process is an integral part of the work: To absorb bodily fluids, Claire preps the animal on a large sheet of paper, upon which she later sketches the final, installed piece, creating an alternate exploration of the idea. Taken together, the various media—initial sketch, installation, final rendering—convey a tension between motion and stillness, life and decay, permanent and ephemeral.

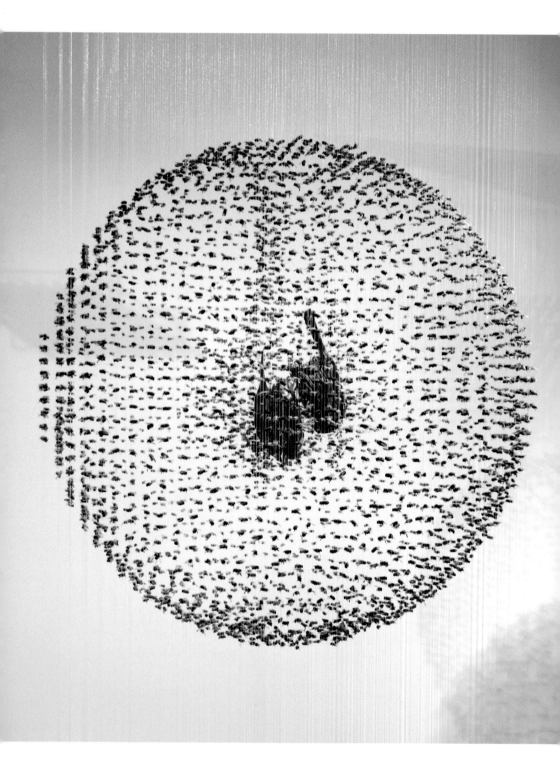

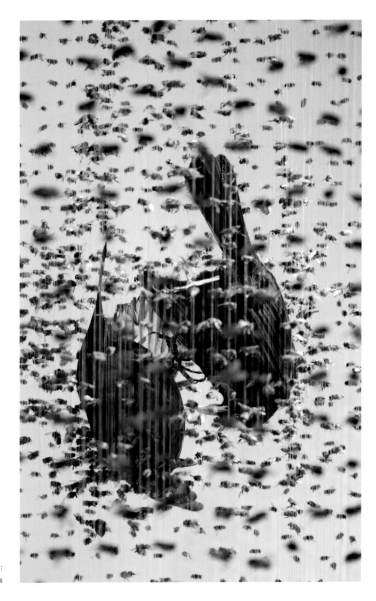

THIS PAGE and OPPOSITE:
The Birds and the Bees

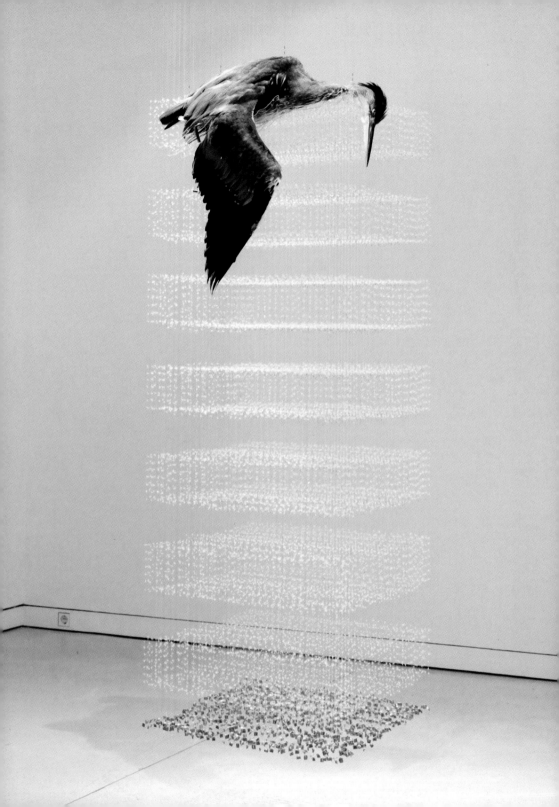

Strange Fruit (detail)

OPPOSITE: *Pedestal*

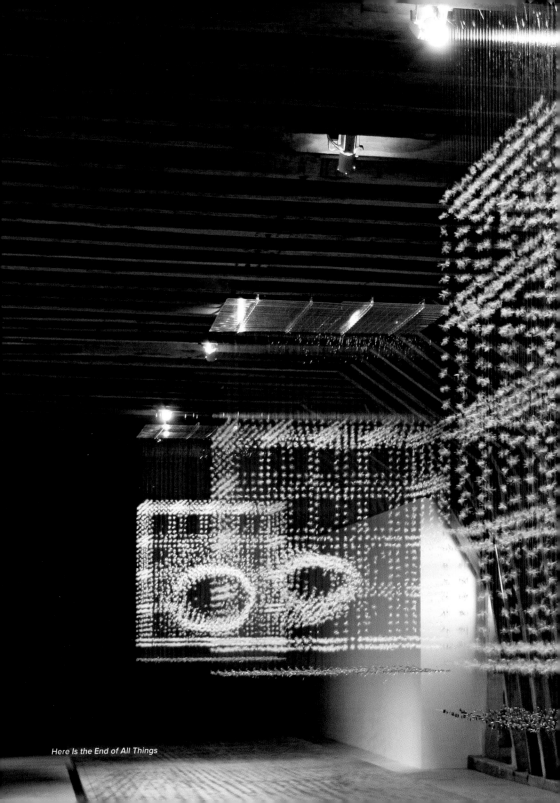

Here Is the End of All Things

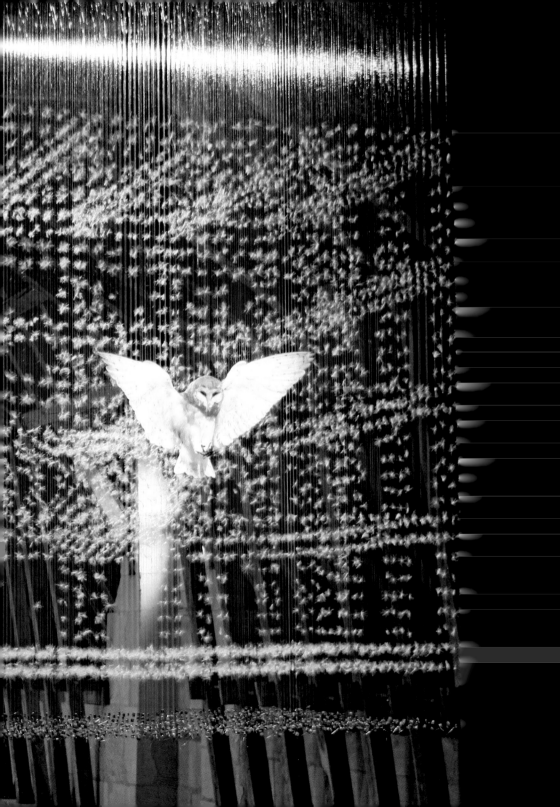

MARK DION

NEW YORK, NEW YORK

An artist, educator, and self-described "amateur naturalist," Mark Dion has been instrumental in advancing the discourse of bio art. His goal is threefold: to encourage artists to work responsibly with taxidermy; to help viewers build a better relationship with the natural world; and to expose how the gallery space itself, far from being neutral, helps shape our understanding of natural history.

Mark's installations typically challenge preconceived notions of how animals should behave—and reveal how those biases influence our conservation efforts. Rather than depict seagulls on a beach or in another natural-environment diorama, for example, Mark places his seagulls in their "true" habitat: trash heaps and landfills. In his Tar Museum series, large birds coated in black gunk critique man's appropriation of nature: A substance born from decomposing animals has been processed by humans in a way that destroys those very animals. The tongue-in-cheek title and Mark's choice to mount the birds atop museum packing crates comments on how institutions perpetuate certain myths.

Mark recently worked with a team of artists to create a site-specific installation along Norway's National Tourist Route, a decommissioned highway featuring scenic attractions like public artworks. He envisioned a cave in which a bear snoozes on a heap of layered domestic waste dating back to Viking times. The bear is artificial; Mark no longer uses real animals in his taxidermy work. This is in part due to legal limitations, but it's also a canny device to inject another layer of artifice into the representation of nature.

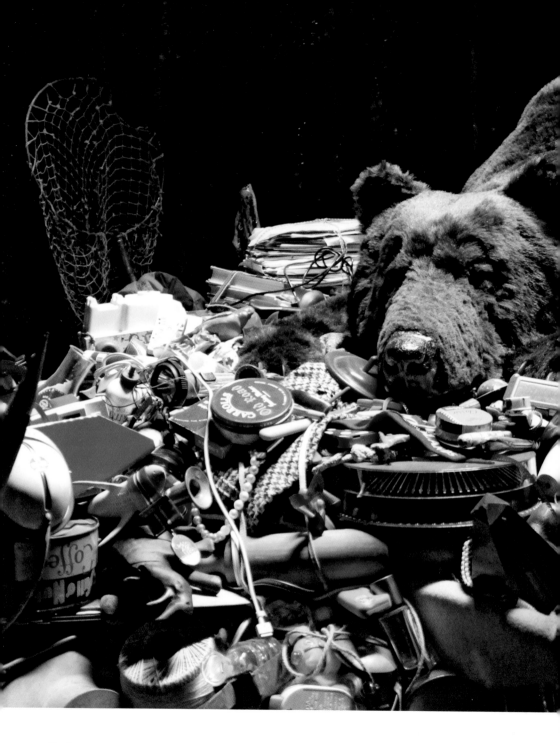

The Den

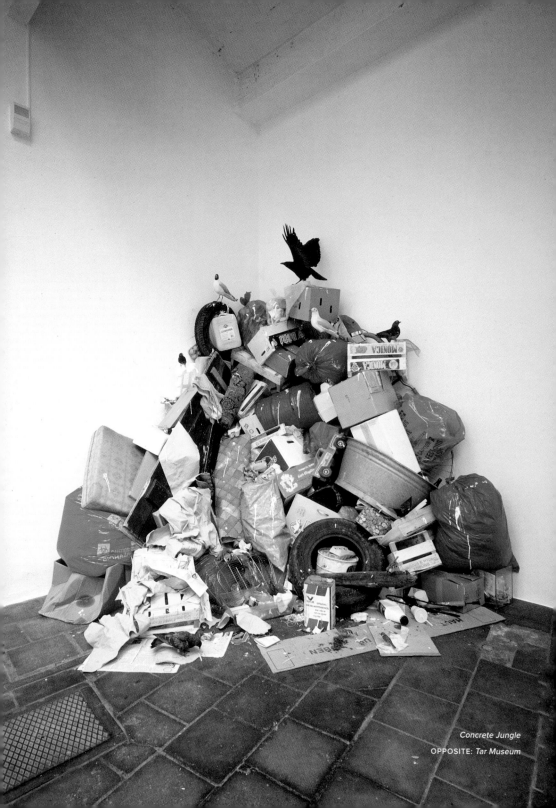

Concrete Jungle
OPPOSITE: *Tar Museum*

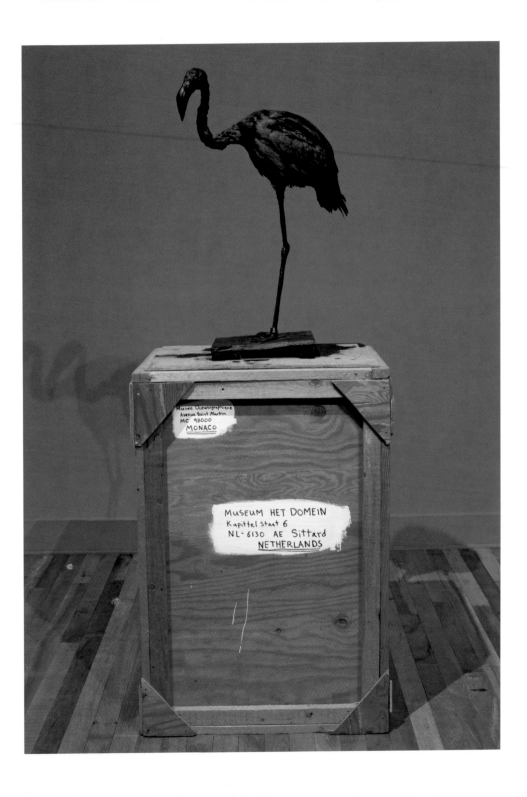

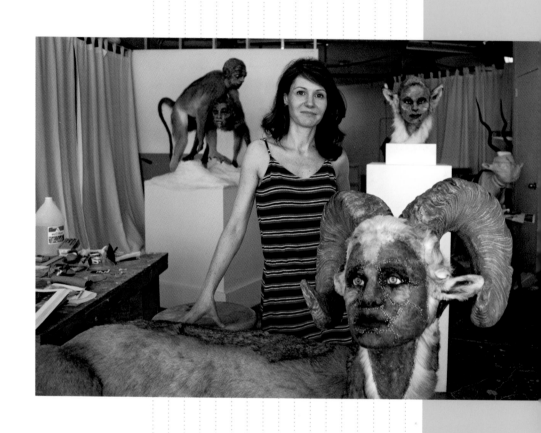

KATE CLARK

BROOKLYN, NEW YORK

Kate Clark's seductively disturbing artwork inspires a double take. Her sculptures have human faces but animal bodies; their shorn skin and anthropomorphic gestures make them look all the more human. They are not a seamless hybrid so much as an uneasy coexistence of man and beast.

Each creation has a unique personality, which Kate achieves by basing its face on an actual human model. To fabricate each body, she mounts tanned hides—primarily larger game like bear, antelope, or wolf—over animal forms, pulling the hide taut over the sculpted visage too, so it looks integral. She then shaves some of the fur to reveal the underlying skin and details the face with pushpins and stitches to draw attention to its gaze.

It is not uncommon to see people leaving the gallery after encountering one of Kate's pieces, only to return for a second look when they are better prepared. While her choice to disturb is deliberate, Kate ultimately wants her audience to relate to the artwork and, by extension, to the animal world. The noble quality of her sculptures prompts us, the viewers, to see ourselves in them. By illustrating the artificial divide between man and animal, Kate propels us to approach the environment with greater compassion.

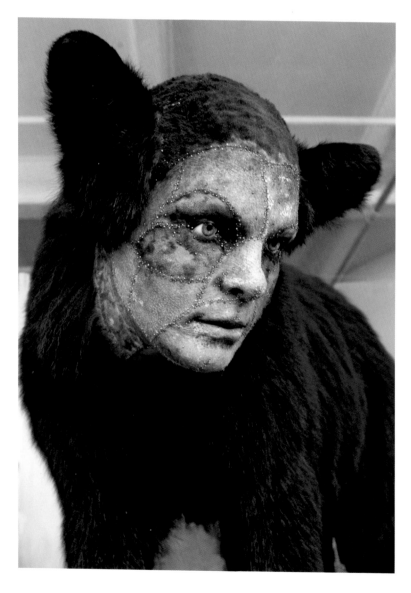

Untitled (Black Bear)

OPPOSITE:

Untitled (Female Bust)

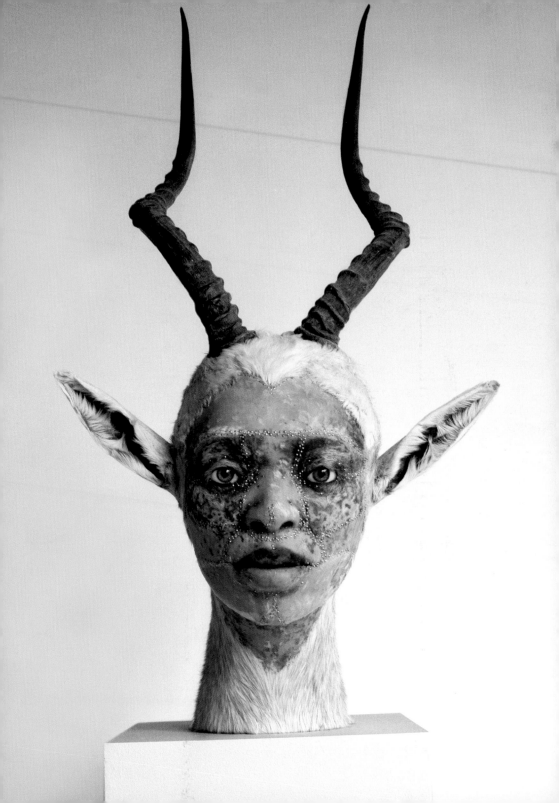

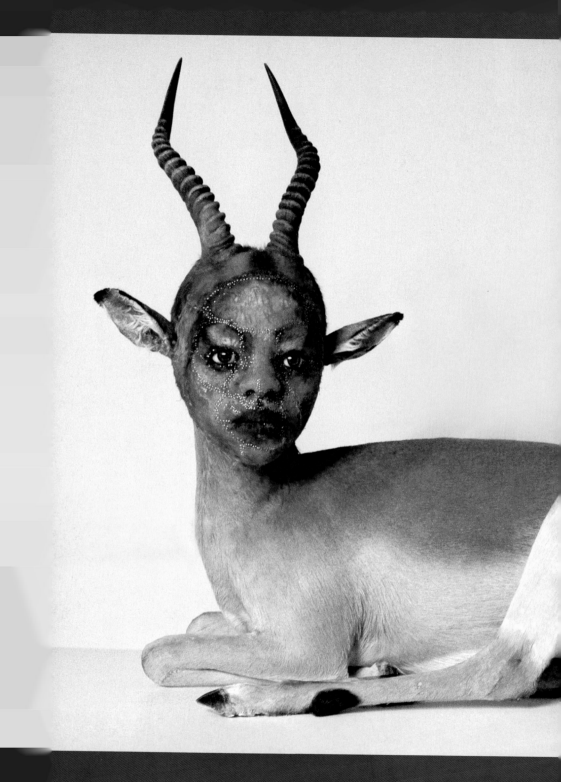

Pray

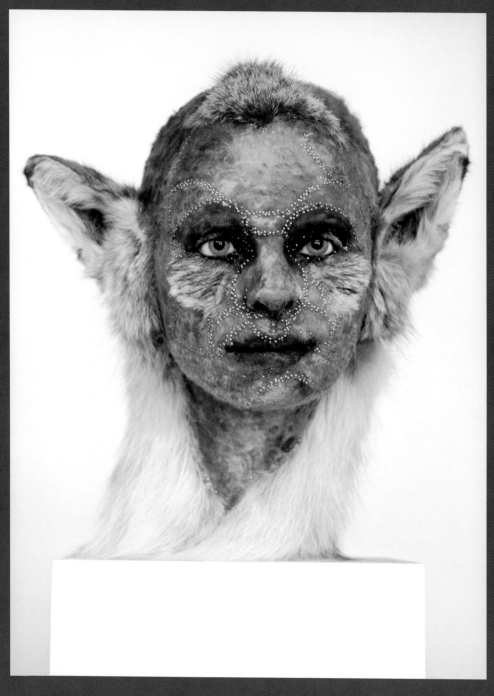

Untitled (Female Bust 3)

OPPOSITE: *Rivalry*

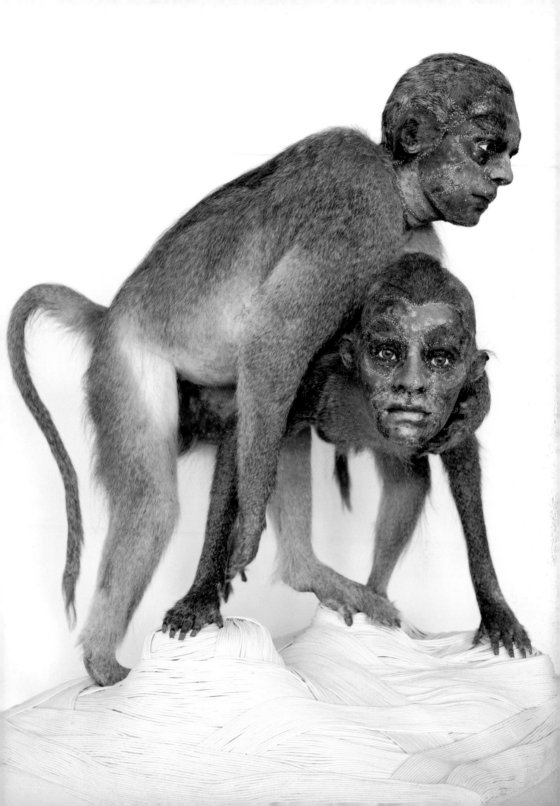

TESSA FARMER

LONDON, UNITED KINGDOM

Tessa is fixated on fairies—a topic that has a strong mythology in her native England. She first encountered fairy lore in a college anatomy class, of all places, and she has since made the little winged beings—their behavior, their societal structure—the subject of her life's work. Tessa "studies" her subject not by observing them in their native habitats, as would an anthropologist, but by *creating* that habitat: elaborate installations in which fairies made from roots and insect wings confront the animal world.

It turns out fairies aren't so nice. They are typically shown attacking, hurting, stabbing, or otherwise dominating the taxidermied animals in their midst. In one piece, a herd of fairies force bees, parasitic wasps, and ants to attack larger animals on their behalf. In another, the fairies stab a fox's mouth. Of course, it is Tessa who places the fairies in such violent scenarios, but she considers herself more of a channeler than a director, surrendering agency to her creations.

Despite documenting her fairies doing terrible things, Tessa seems to empathize with them. She does this by building the subjects' point of view into her work. Chaotic orgasms of activity, her installations can be understood only by getting up close to them; her exhibitions often incorporate little binoculars for this reason. Viewed from the level of the fairy, the individual characters' actions come into focus and the story unfolds. Tessa's work suggests that only by studying dark forces in a proto-scientific manner can we understand—and come to terms with—them.

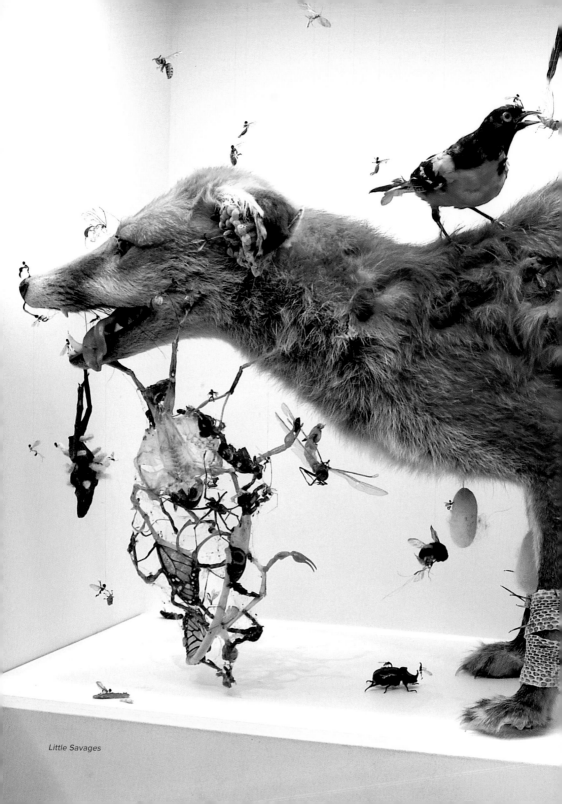

Little Savages

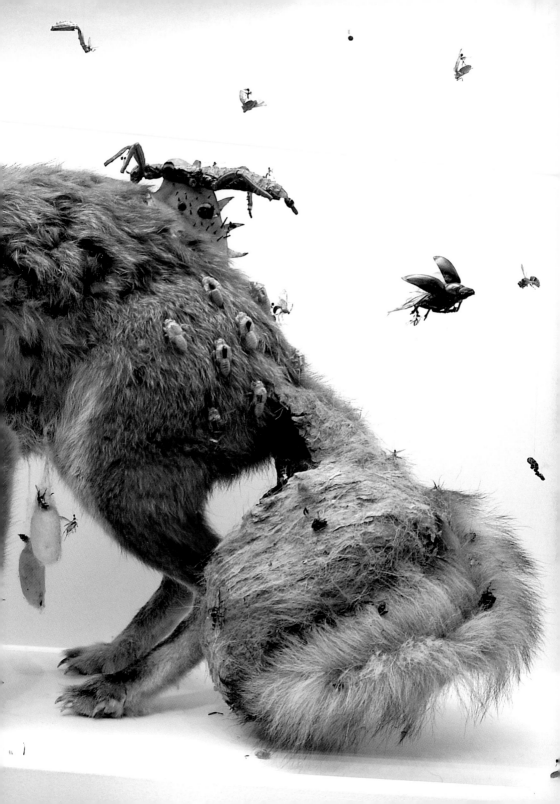

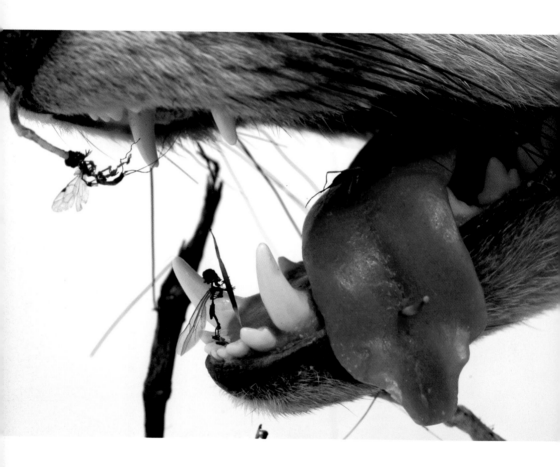

ABOVE and OPPOSITE: *Little Savages* (details)

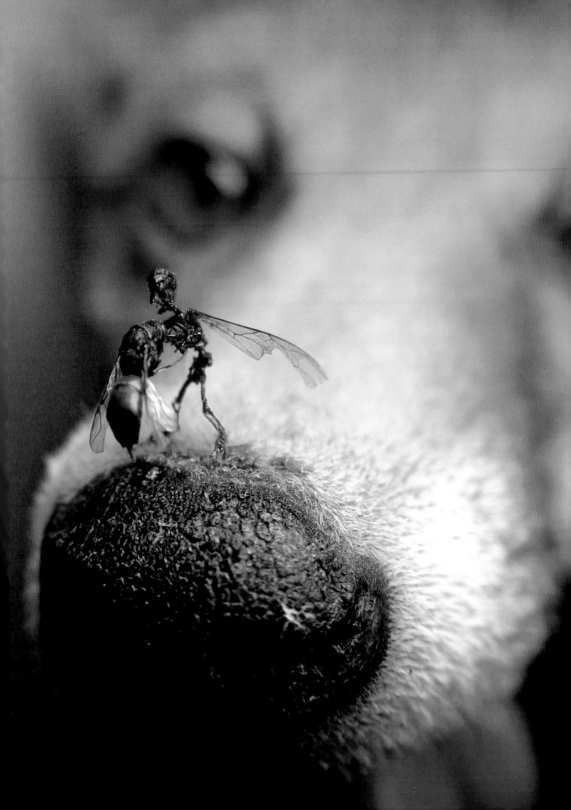

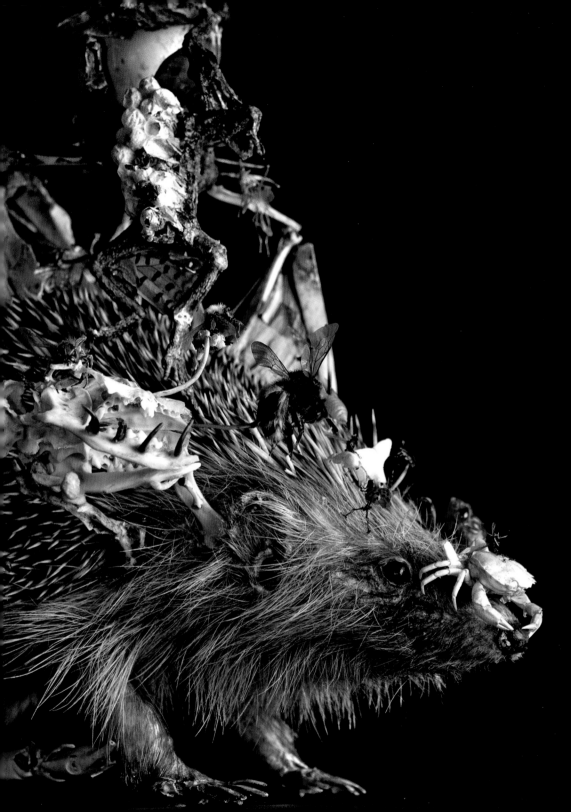

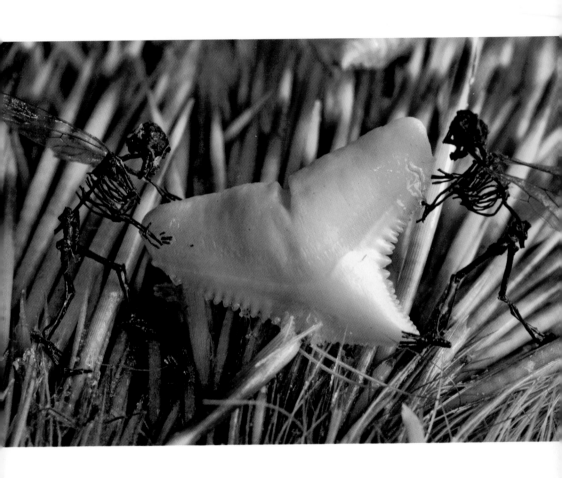

ABOVE and OPPOSITE: *The Fairy Horde*
and the Hedgehog Host (details)

MIRMY
WINN

VANCOUVER, CANADA

Weasels are Mirmy Winn's bête noire and her idée fixe, objects of both fear and affection. Her mounts typically feature the creatures—which she calls "cute little killing machines"—in silly scenarios. The work is fueled by Mirmy's childhood memories of her parents, who had an acute if irrational terror of the weasels that frequented the family's yard. Here, they serve as a stand-in for feelings about death and fear.

Mirmy has built a career rescuing discarded and botched weasel taxidermy mounts. Her first such "rescue" was in 2003, when she purchased a poorly mounted weasel on eBay. It looked pathetic, with missing eyes and messed-up teeth, but most offensive to her was that it sat on a birch branch—an unfitting monument to its life, Mirmy thought. The artist freed the weasel from the branch, painted a box to house it, and renamed it Mr. Sizzles.

Mirmy finds her materials in online auctions, thrift stores, and yard sales. She frames each creature in a display vitrine decorated in the style of a Mexican Day of the Dead shadow box, complete with painted scenes of zombies, half-robots, and other misfits of pop culture. Some boxes are rigged to function as fortune-tellers: Ask a yes or no question, press a button, and get an answer. Not coincidentally, *weasel* means "to equivocate"—a state the work itself embodies by interweaving love and hate.

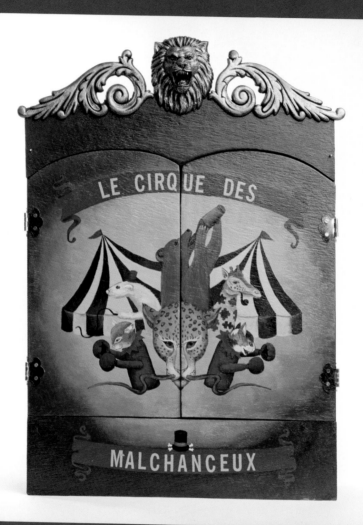

ABOVE and OPPOSITE: *Le Cirque des Malchanceux*

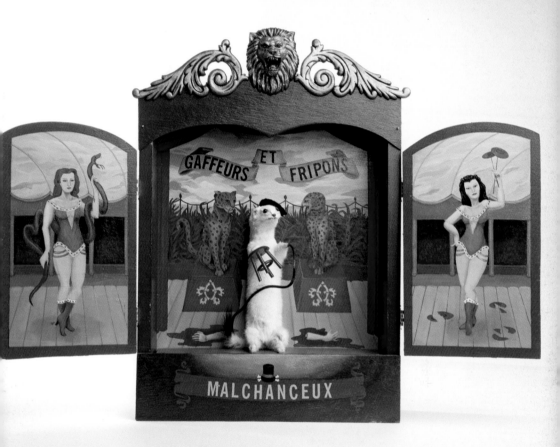

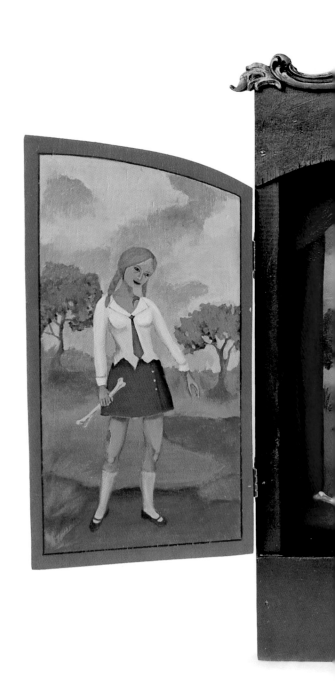

Brains!

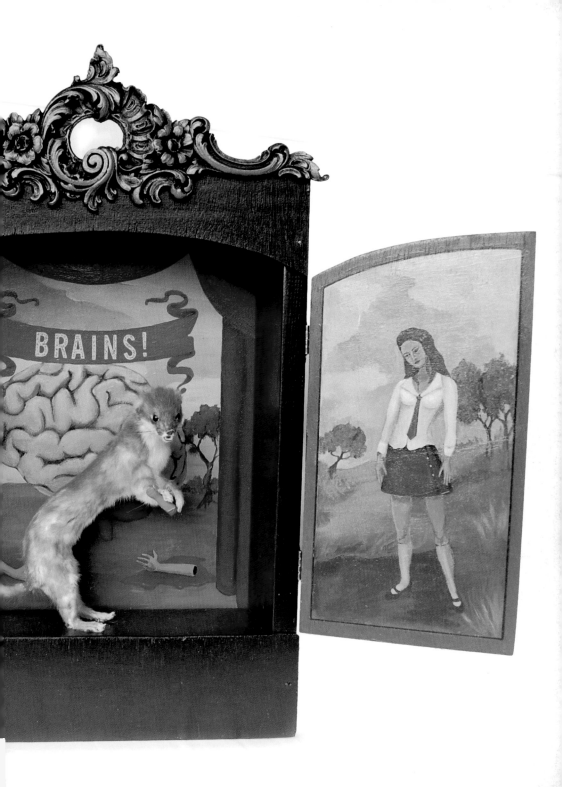

NATE HILL

NEW YORK, NEW YORK

Nate Hill loves to court controversy and induce squeamishness. His preferred medium is performance art, which offers ample opportunity to engage with and destabilize his audience. He is unafraid to go to places that are unpleasant—for him as well as for his followers. At a recent taxidermy competition, for instance, Nate invited audience members to hang ornaments made of pickled animal parts on a Christmas tree while he sang "O Tannenbaum."

His NYC Chinatown Garbage Taxidermy tours involved group scavenger hunts for fish guts and frogs legs in neighborhood trash cans. Dressed up as a milkman or paratrooper, he would distribute latex gloves to participants in the tour, who were encouraged to stitch together the remains to make "personal taxidermy" under Nate's tutelage. Although the experience could prove unsettling, the artist's twisted sense of humor and complete commitment to his role spurred people along.

Similarly mischievous, if less confrontational, is the New Animal series, where Nate collected roadkill throughout his native Florida and grafted together mismatched parts to create new species, like a twenty-first-century Doctor Moreau. He preserved them in glass jars, the lablike display a nod to his day job working with fruit flies in a research facility. That investigation birthed ADAM (acronym for "a dead animal man"), a full-size Franken-human that "lived" in fish tanks in his walkup apartment; private showings were arranged by appointment.

Even Nate's recent decision to stop working with animal parts had a performative aspect. To symbolize the break, he ritualistically buried his New Animals throughout Central Park. Shedding his past life, the artist is now free to move on to his next projects that push boundaries—and buttons.

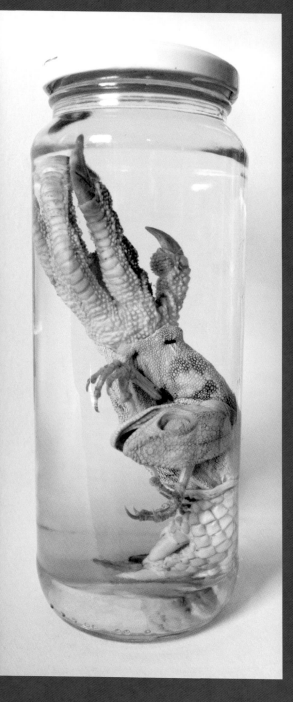

New Animal #20

OPPOSITE, LEFT: *New Animal #31*

OPPOSITE, RIGHT: *New Animal #7*

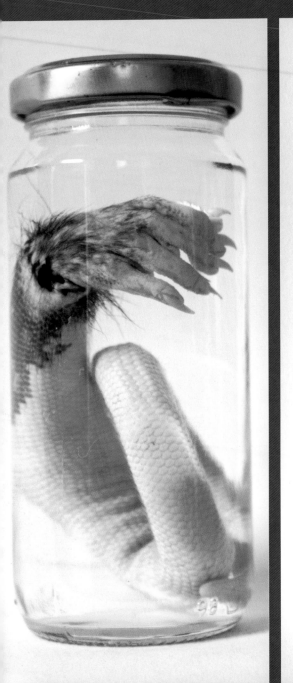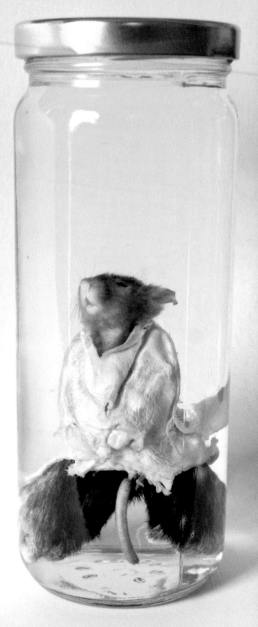

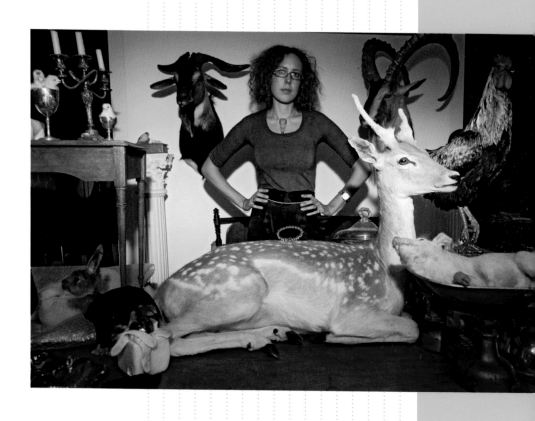

JULIA
deVILLE

MELBOURNE, AUSTRALIA

Death is a heavy topic, one most of us avoid discussing or even contemplating. Julia deVille's taxidermy forces us to do both by celebrating the unexpected beauty in death. Her mounts are frequently ornamented with beads, garments, and other decorative touches: A white pig is bejeweled with diamonds and pearls; a lamb is dressed up in Victorian baby boots; a turtledove sports black-diamond eyes. By dazzling us with death, she desensitizes us to it, familiarizing us with what we fear.

Such embellishments reflect Julia's training in fine-jewelry making. In addition to creating thought-provoking taxidermy, the New Zealand native designs a popular jewelry line named Disce Mori—a Latin phrase meaning "learn to die," which is also her personal credo. The term originated during the height of the bubonic plague in the fourteenth century, a time when people embraced the inevitability of passing on. For Julia, taxidermy art is perhaps the truest embodiment of this motto, forcing viewers to confront the ever-present nature of death in a physical form.

Taxidermy is also a vehicle for the artist to convey her ethical stance. A vegan, Julia only works with animals that died of natural causes. She frequently uses lambs, pigs, and calves in her mounts to protest industrialized farming and the treatment of animals as a commodity. Many pieces are arranged on silver platters, elaborate soup tureens, and copper pots, which serve as pedestals, giving each of her subjects a noble memorial. One recent creation, however, is much more direct: A calf hangs from the ceiling, pearls streaming from its cut throat.

As an advocate for confronting the eventuality of death during one's lifetime, Julia walks the talk: She has donated her body to the Institute for Plastination, to be preserved for the purposes of medical study.

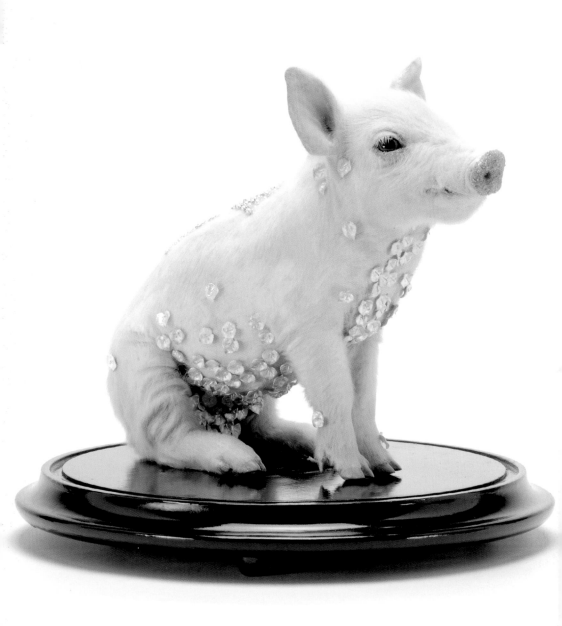

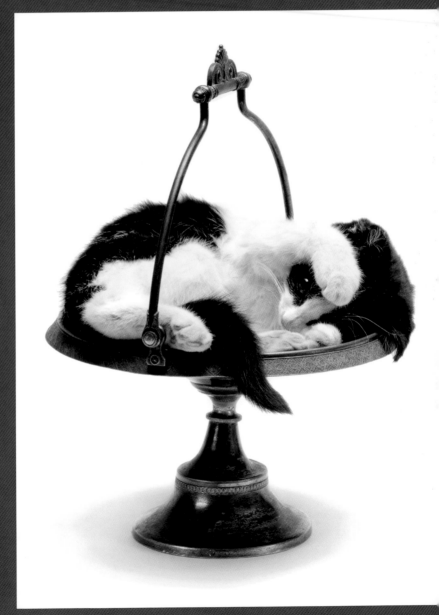

Gâteau

OPPOSITE: *Orcus*

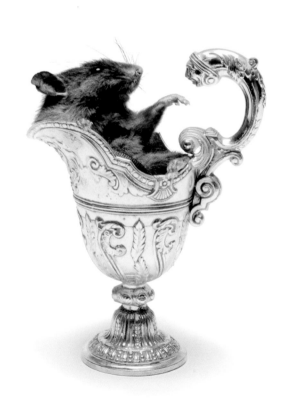

Plague

OPPOSITE: *Iēsus Nazarēnus,
Rēx Iūdaeōrum*

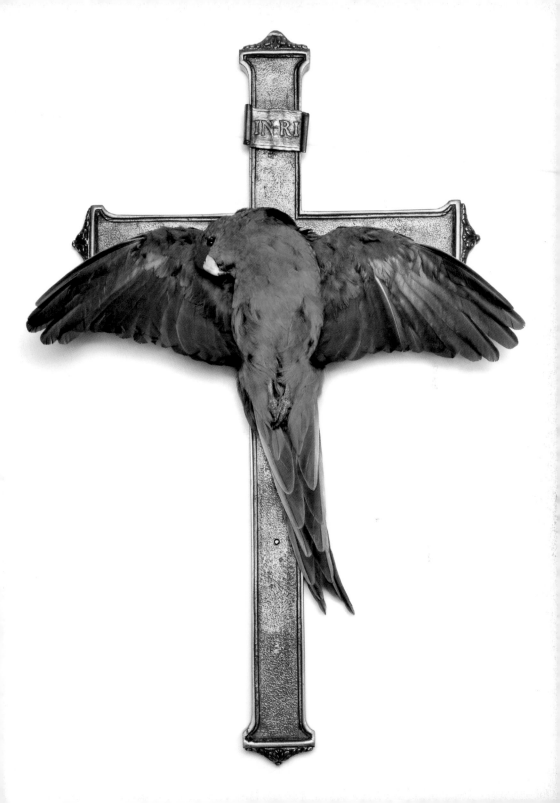

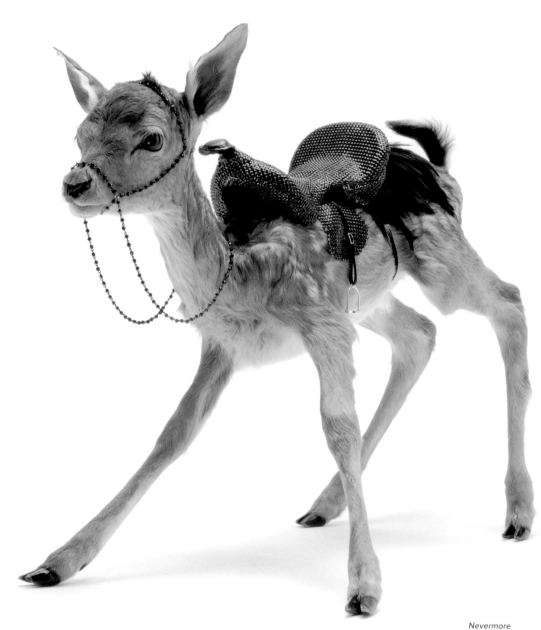

Nevermore

OPPOSITE, ABOVE: *Charon*

OPPOSITE, BELOW: *Grief*

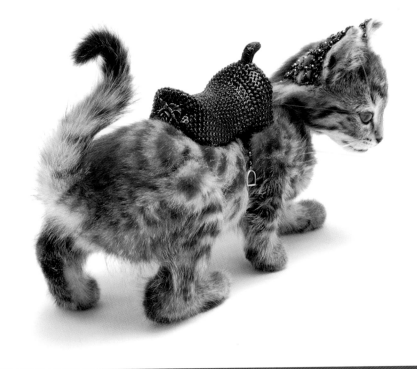

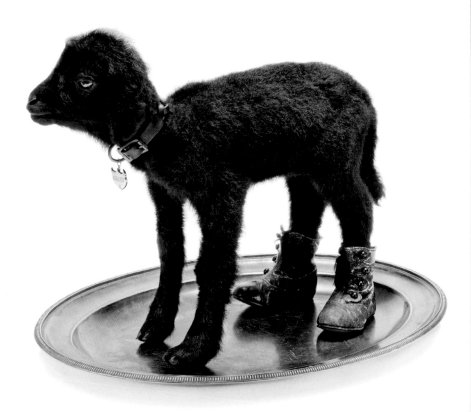

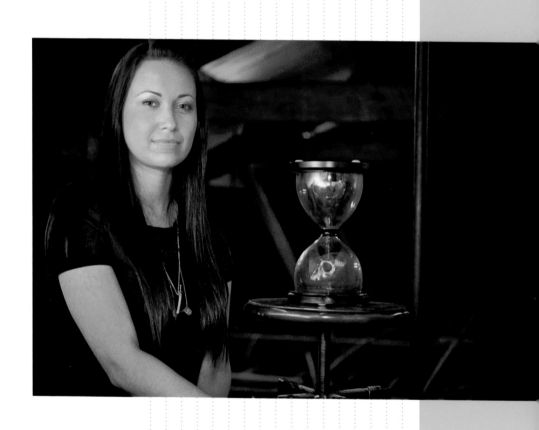

LISA
BLACK

AUCKLAND, NEW ZEALAND

Lisa Black's taxidermy has a bionic quality—part animal, part machine. She "fixes" broken mounts, purchased from auction websites, by suturing them back together with mechanical components. A deer gets an extra spring in its step courtesy of an artificial knee. A wind-up mechanism is spliced into a crocodile's spine. Vervet-monkey craniums are enhanced with antique clock and watch parts—reminiscent of nineteenth-century anatomist Claude Beauchene's "exploded" skulls.

At first glance, these modified pieces seem functional, as though you could switch them on and they'd spring to life. But the augmentations are strictly for ornamentation—and to convey a larger message. By highlighting her "repairs," and thus her own role in reanimating the mounts, Lisa complicates the relationship between technology and nature, and winks at man's not-so-benign influence on the latter.

There's an elegance and delicacy to the work, but a desire for control is also evident. Lisa epitomizes the artist as creator, giving these broken, discarded animals a new lease on life while refashioning them according to her vision. It's her way of imposing order on a chaotic world. Lisa's latest series, in which oversize hourglasses are filled with black sand that alternately conceals and reveals gilded skulls housed in each bulb, expands on that idea. Like all her work, these wed nostalgic elements and a Futurist aesthetic to symbolize the passage of time, the eventuality of passing on, and the possibility of rebirth in a better-designed form.

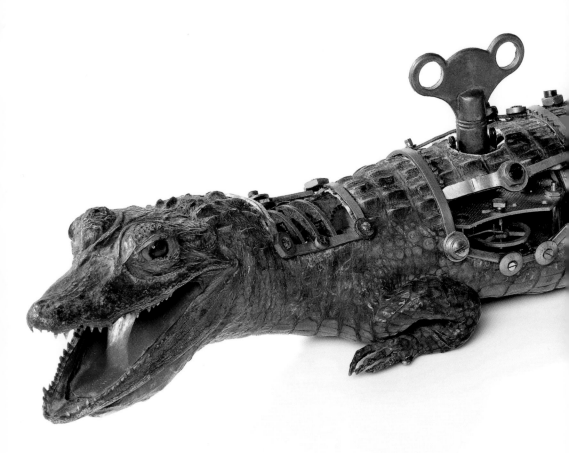

Fixed Baby Crocodile

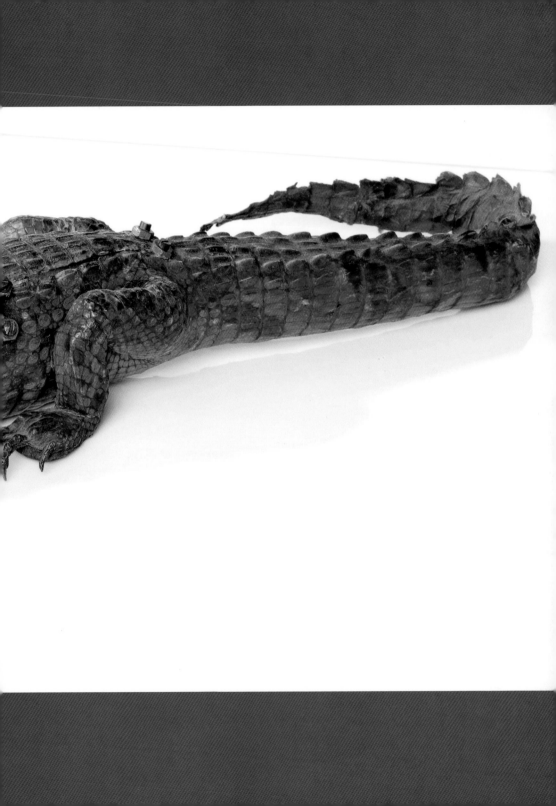

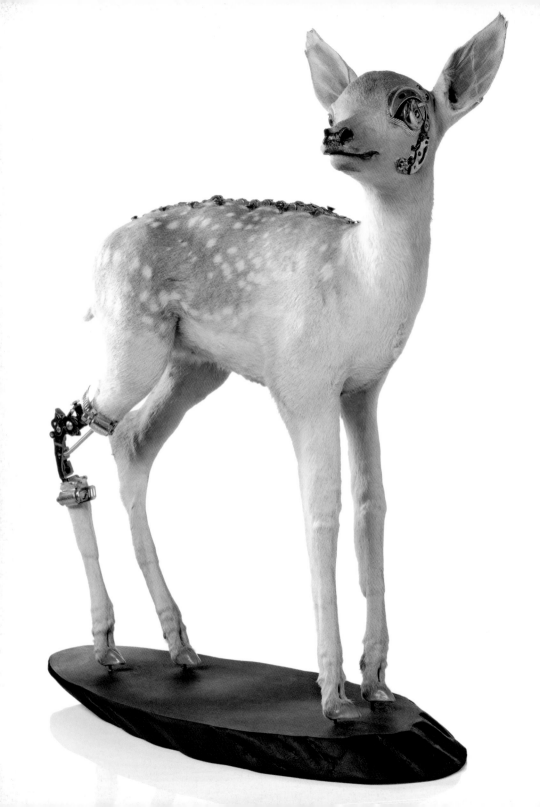

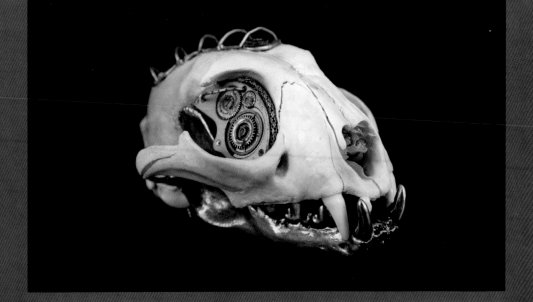

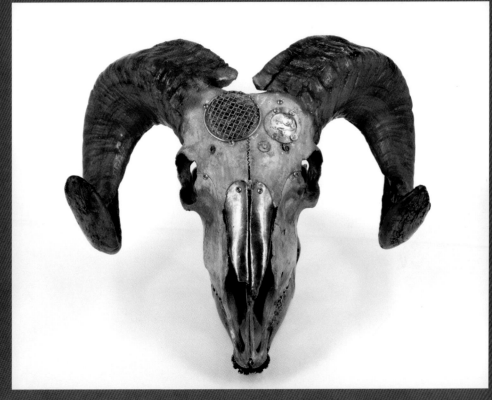

THIS PAGE, TOP: *Departed Caracal*

THIS PAGE, BOTTOM: *Departed Ram's Skull*

OPPOSITE: *Fixed Fawn*

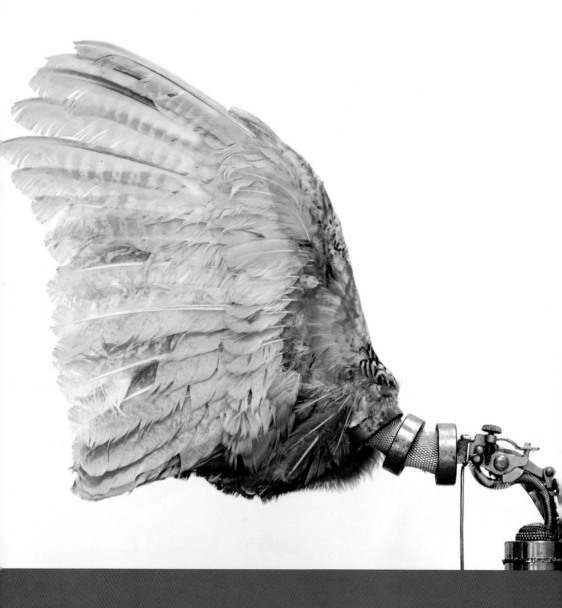

Departed Pheasant Wings

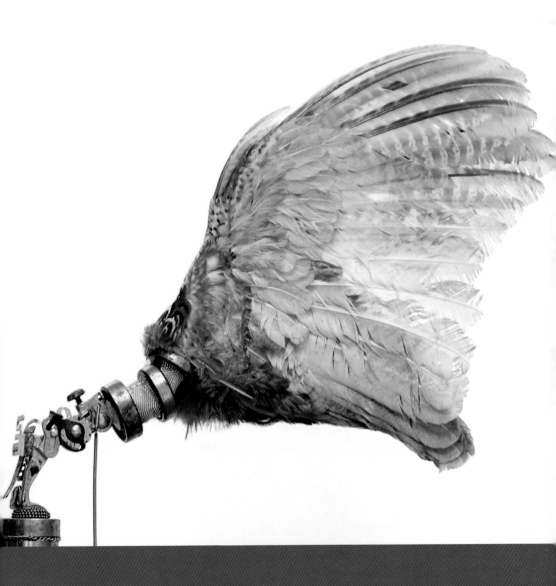

JAMES PROSEK

NEW HAVEN, CONNECTICUT

James Prosek came to the medium of taxidermy via a related field: natural history. Obsessed with trout from a young age, James embarked on a mission to catalog the species' manifold beauty in watercolor. While an undergraduate at Yale, he published an illustrated history of the North American trout in the vein of an eighteenth-century naturalist—a feat that earned him the nickname "an underwater Audubon." He has since set out on similar explorations, retracing the footsteps of Izaak Walton, writing about fly-fishing in Mongolia, circumnavigating the globe to paint trout, and tracking butterflies and eels around the world.

James's quest to achieve the most lifelike depiction of his subjects—by preserving specimens in the field—is what inspired him to learn the practice of taxidermy. But what began as a study tool for his paintings morphed into an artwork in its own right, as the naturalist started posing animals in habitatlike tableaux fashioned from handmade clay flora. These dioramas function on two levels: As source material, they help him achieve verisimilitude in his paintings; as self-contained sculptures, they expose the degree to which said paintings—and, indeed, science itself—are artificial constructs. James typically exhibits the two media side by side.

Lately his taxidermy work has taken an even more subversive turn, depicting animals as mutants that have adapted to their environments. A beaver grows a chain-saw tail to help him chop trees, a fox sprouts wings to escape hunters. Exploring the intersection of documentation and imagination, James uses art to expose the limits of science—and to blur the boundary between them.

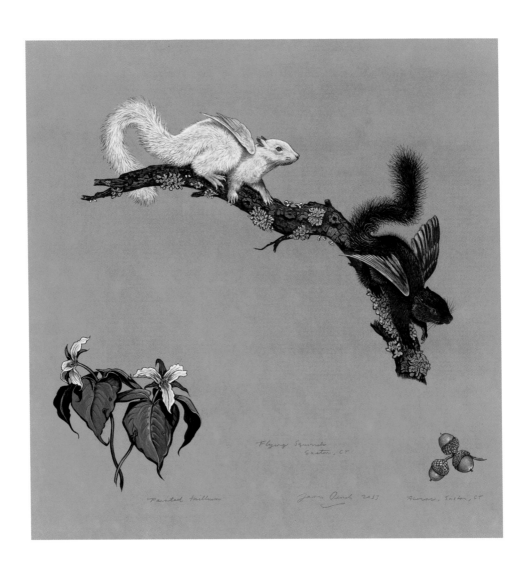

Flying Squirrels

OPPOSITE: *Flying Squirrels*

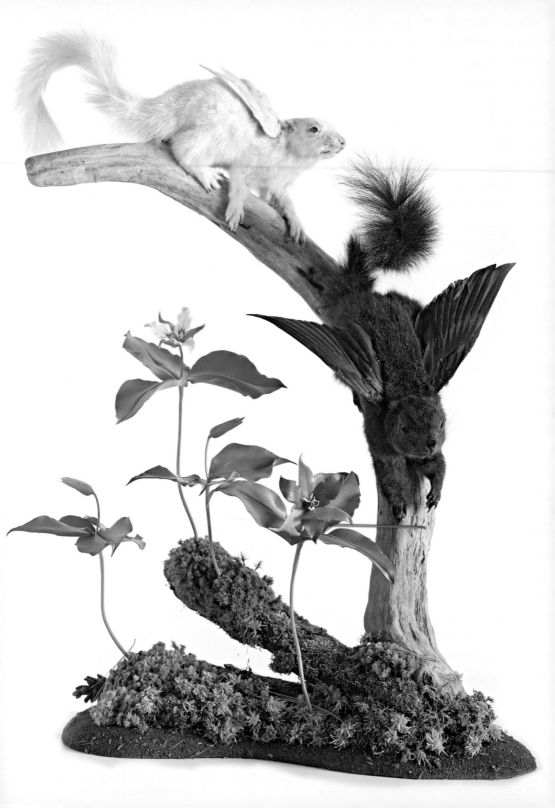

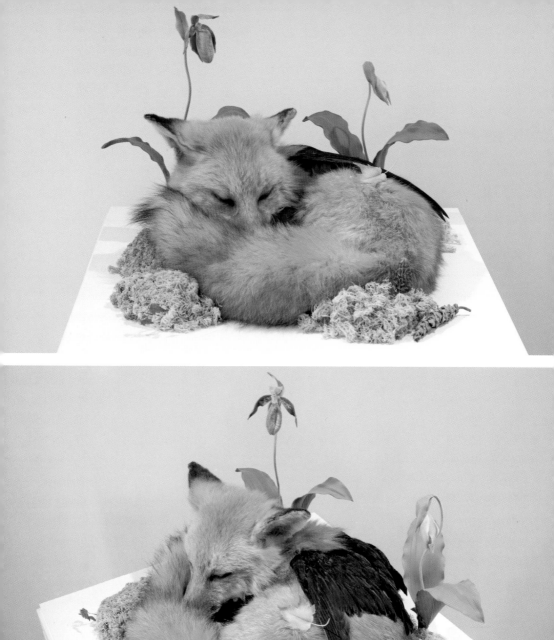
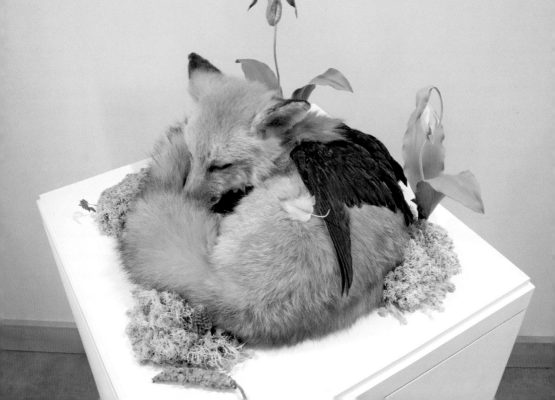

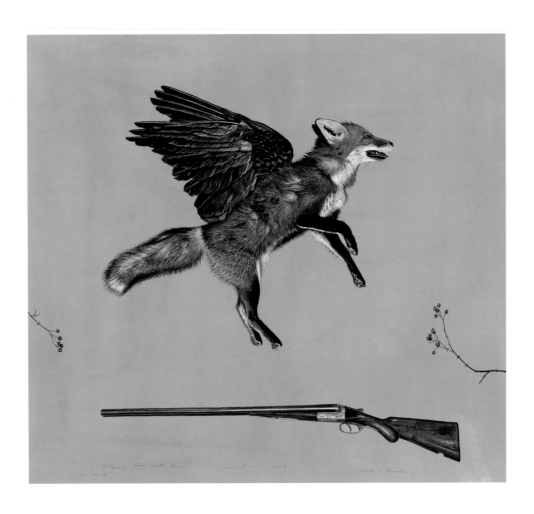

Flying Fox with Prussian Firearm: The Fox Hunt

OPPOSITE, BOTH: *Flying Fox with Lady's Slippers*

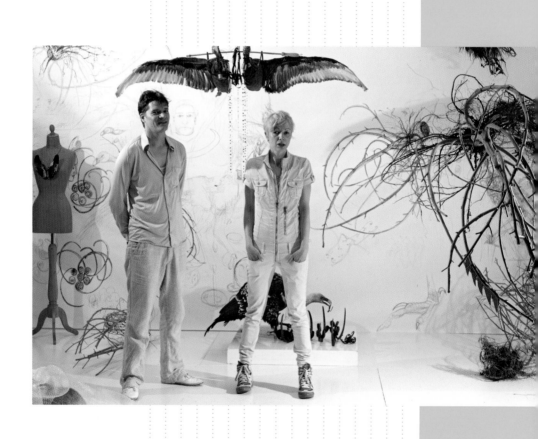

AFKE GOLSTEIJN & FLORIS BAKKER OF
THE IDIOTS

WEESP, NETHERLANDS

Afke and Floris met as students at Rietveld Academie. They began collaborating under the name This Work Must Be Designed by Idiots—an expression of youthful rebellion against Dutch culture. Their work was appropriately in-your-face and often involved dead animals for shock value (in one piece, a faceless cat looked into a tin of cat food containing the cat's face).

Still working together, they've shortened their name, and their sensibility has grown up; they still use dead animals, but now to craft a more nuanced story. Each piece tells a fable in which an animal or inanimate object is used to illustrate a moral lesson. The juxtaposition of materials—typically, fur, metal, glass, and fabric—often leads the story. A peacock's plumage turns into a beautiful garment. A fox with exposed metal ribs plays the role of Thanatos, a personification of death.

Their most famous piece, *Ophelia*, is a diptych of sorts: Bulbous forms of gold seem to bubble out of the torso of a lion asleep; in the companion piece, the lion's hind quarter is sliced open to reveal sections of amethyst. Both elemental stones are often found near each other in nature but present very different narratives—just like the artists themselves.

Ophelia

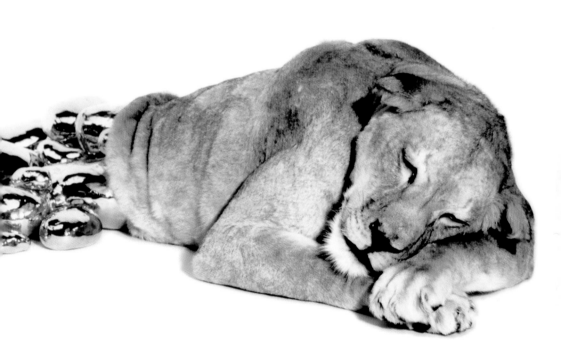

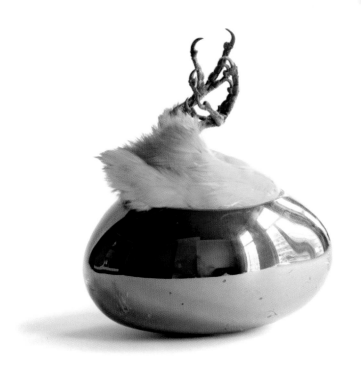

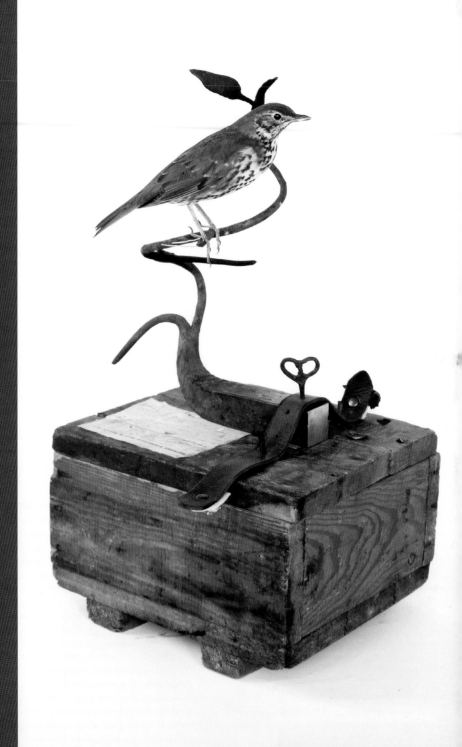

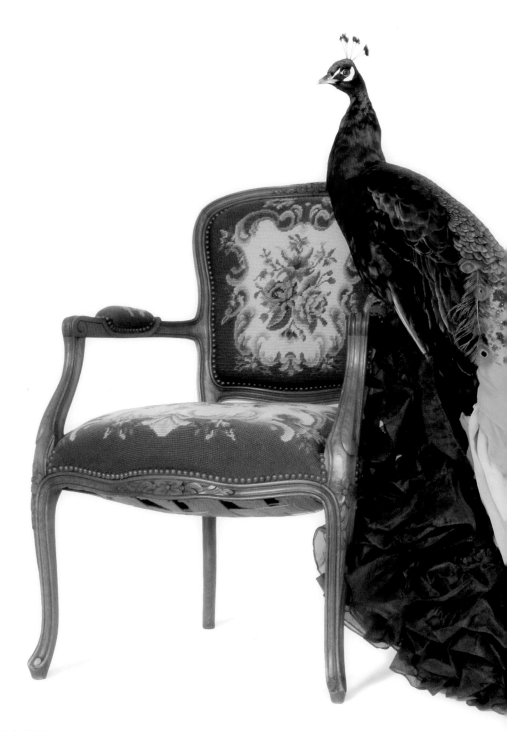

This Seat Is Taken

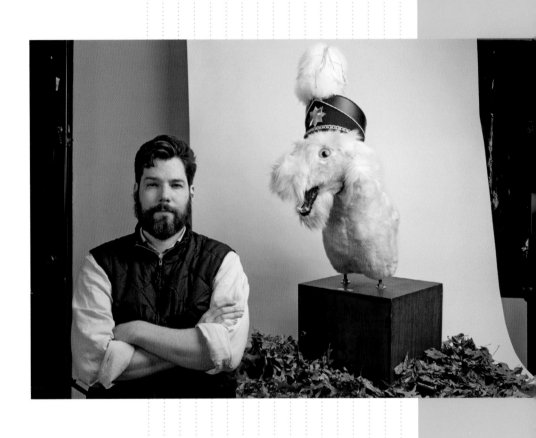

ROBERT MARBURY

BALTIMORE, MARYLAND

I am a practitioner of "vegan" taxidermy, utilizing discarded stuffed animals in lieu of real animal parts in order to bring childlike fantasy and wonder into contemporary art through humor and the ridiculous.

My Urban Beasts series started from an exploration of stuffed animals tied to the grilles of delivery and garbage trucks in New York City. Borrowing concepts of urban naturalism, specifically the way that animals adapt to living in populated cities, I gave the rotting stuffed animals a secondary, feral existence.

Originally, these Urban Beasts were presented as public art pieces in parks and underused space in the urban environment, hidden in bushes and along fences. To bring the artwork indoors, I borrowed techniques from naturalists and conservationists by presenting the beasts within environmental dioramas and large-scale photographs (à la John James Audubon's Elephant Folio illustrations). In keeping with this naturalist/conservationist style, I created names, photos, habitat details, and individual histories of each creature in my *Anthology of Imaginary Urban Beasts*.

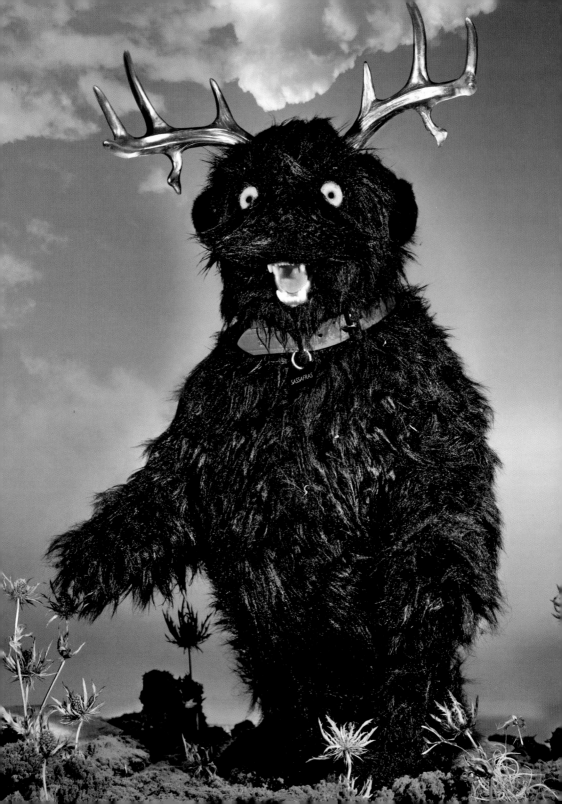

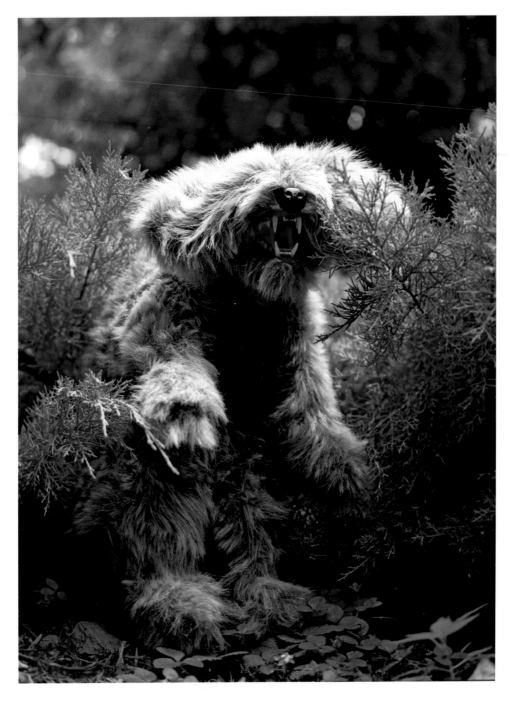

Gus—Wild Hammerhead

OPPOSITE: *Sassafrass*

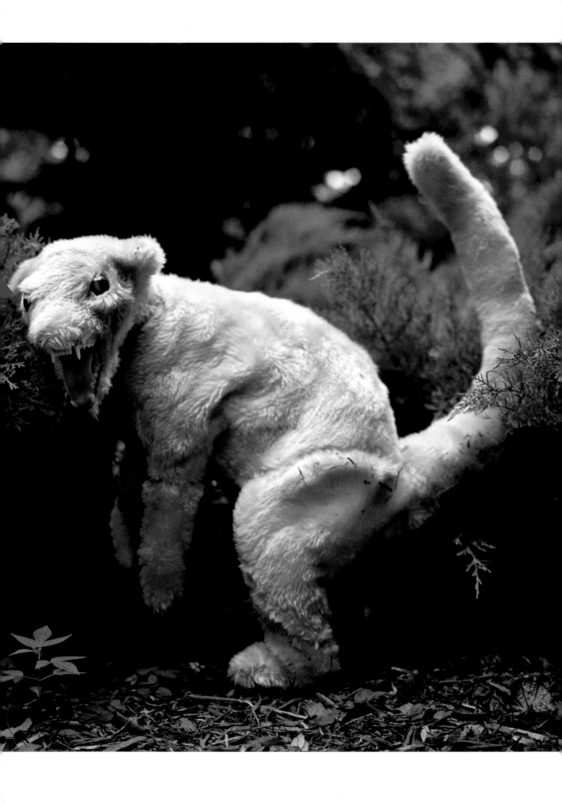

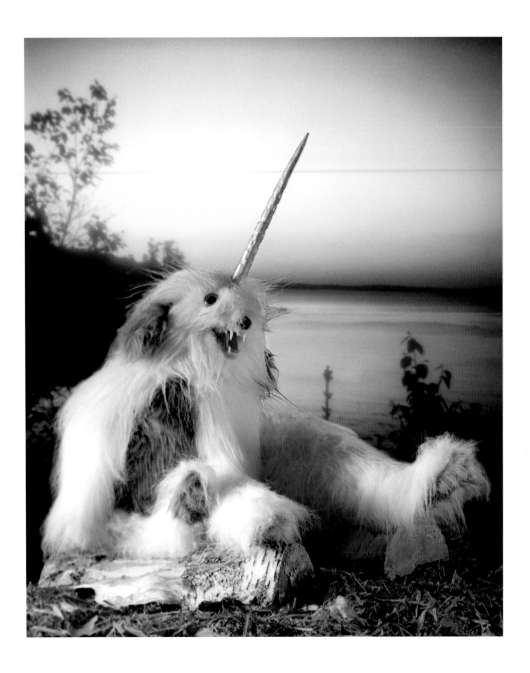

Nardog

OPPOSITE: *Eleanor—Trouble*

THE
WORKSHOPS

f you're interested in creating your own taxidermy work, the following workshops are a great place to start. Together they cover techniques to preserve every part of an animal, from tanning the skin with a brain to cleaning and bleaching bones and the skull, from wet preservation of the carcass to taxidermy of the skin or feathers. In each workshop, I will describe one technique, with some possible variations you might want to employ, depending on your mount and the tools available to you. You might choose to do some of these steps in a different order, and you may substitute materials. When you are ready to expand your practice to larger (or imaginary) animals, the basic principals are the same, but you may want to seek out additional resources and references (see page 224).

Creating an artistic practice requires patience, lots of hard work, and a dedication to challenging yourself. As in any other artistic field, in taxidermy art you need to take time to understand the history of the medium. Study the vocabulary, learn about the artists working in the field, and get to know the general artistic landscape. Take some time to familiarize yourself with the members of the canon (pages 16–25), the laws that apply to taxidermy (pages 10–12), and the individual artists presented in this book (pages 26–171).

The best practice is to begin simply and experiment over and over again until your work becomes more competent and complex. All of the artists in the survey spent years exploring their voice before producing the amazing work in this book. Art is a series of experiments, and expect a lot of them to fail. Keep plugging away, and you will be rewarded.

A NOTE ON ORIGINALITY: Just because you are self-trained or following the DIY approach does not mean you should copy another artist's work. Practicing artists rarely see imitation as a sincere form of flattery. Discovering your own path and personal style, and striving to make art that expresses what you care passionately about, are crucial ingredients for success.

Before You Begin

Before trying taxidermy on your own, there's some legwork you can do to help make the process more successful. In addition to your skill and imagination, simple preparations can often have the biggest effect on the outcome of your work. Your workshop, the materials you use, the notes you take, and the techniques you explore will all have an impact on your final project. Establishing a dedicated practice from the beginning will benefit you in the long run.

Setting Up a Workspace

Unlike other DIY projects, working with dead animals has health risks, such as bacteria that can cause disease, as well as a stink factor, so there is a real benefit in having a workspace that is dedicated to the task, or at least a safe place for work to sit undisturbed.

A lot of your work will be slow and focused, so a good chair and proper lighting will really help during long days. You will benefit from having your tools accessible as you work. Nothing is more frustrating than digging through toolboxes when you should be mounting. No workspace will seem large enough as your practice grows, but cleaning up after each session will go a long way to keeping you from becoming overwhelmed.

Essential Tools and Materials

While each project might require specific tools, a basic setup should include these items. Use these tools for taxidermy only (your spouse, roommate, or parents will appreciate not finding blood and guts on their craft scissors).

Pen or pencil and journal
Cardboard or butcher paper
Plastic bags
Paper towels
Latex gloves*
Borax (available in grocery stores
 as a natural washing soap)
Scalpel
Scissors
Wire brush

Clothespins
Dish detergent
Bucket
Hardwood sawdust or
 corncob grit
Sandpaper
Strong knife
Woodworking tools
Strong, waxed thread or twine
6-lb. fishing line

Wire of various gauges

Leather needle (circular or suture work well)

Hide paste, Liquid Nails, or latex caulk (100 percent latex with no silicone)

Insect or euro pins

Spray bottle filled with water

Woodworking tools

Paper clips

Air-dry clay

Cotton

Hair dryer

If you're allergic to latex, nitrile gloves are a good alternative.

Sourcing Animals

If you choose not to hunt animals for your mounts, here are some no-kill options:

• Roadkill is a great source for dead animals—just remember that roadkill laws vary, so you will need to familiarize yourself with state and national laws. (See page 176 for more information on collecting roadkill.)

• Pet stores and animal food suppliers sell frozen "feeder animals" like mice, guinea pigs, rabbits, piglets, and chicks, intended for snakes, raptors, and other carnivorous domestic pets. (See Supplies, page 228, for some online sources of feeder animals.)

• Hides and skins can be found online through eBay, Taxidermy.net, and other auction sites. It remains your responsibility to follow up on the legality of the product you purchase, however, since most websites are not able to adequately monitor their users.

• Ethnic food markets and butchers are good sources for animals that have already been killed for the food stream, like frogs, chickens, and fish.

• If you are interested in repurposing a mount, they can be found at yard sales, junk stores, and online auctions. Again, just because you located a mount does not mean that it is legal for you to purchase, possess, or resell it.

• Local farms can be a good resource for animals that die at birth or of natural causes.

• Friends and family are great resources as well. Once your interest in taxidermy is known, people often come out of the woodwork with donations—seriously, they will bring you roadkill, found dead animals, and sometimes deceased pets.

Collecting Roadkill

If you choose to use roadkill for your mounts, keep in mind that collecting roadkill is not legal in many states. Before you begin collecting, you *must* contact your local wildlife services to learn your state's rules and regulations. Some require a hunting license and allow you to take roadkill animals only in the season when the animal is legally hunted. Others require that you contact a ranger to receive a tag before you are able to take the dead animal. To make matters more complex, many animals are illegal to possess no matter how they die, and some animals might be legal to possess but not legal to sell.

A list of state wildlife offices is provided in Legal Resources (page 229). Learn the laws so that you can comfortably practice your art and not make things harder for other taxidermists and artists. Taxidermy is a community, and by respecting the laws you are respecting everyone else in that community. Be sure to account for each piece that comes through. Keep a log of what the animal is, where you got it, if it has tags, what project you produced it for, and whether or not that project was sold. This will help you follow the law much more easily.

Before collecting your roadkill, ask yourself the following questions:

• **Is this animal alive, but injured?** If so, contact the nearest animal rescue for advice.

• **Is it legal to collect this animal in my area?** If you have any doubts, leave the roadkill alone.

• **Was this animal someone's pet?** If you find the corpse of a cat or dog along the side of the road, first look for a collar and, if possible, contact the pet's owner. If the animal does not have a collar, whether you collect the animal is up to you. But know that if you choose to use domesticated pet remains in your artwork, it may elicit negative

responses from pet lovers. Nothing turns a community against a taxi-dermist faster than the suspicion that he has murdered someone's pet for a mount.

• **How much trauma has been sustained? Can I use the remains?** This visual assessment will get easier with experience. Some trauma makes scavenging too difficult. The more holes in the skin, the more work you will have to repair.

• **How long have the remains been on the road?** The longer the animal remains on the road, the better the chances of bacteria attacking the skin (causing slippage, an irreparable occurrence where the fur "slips off" the skin). Keep in mind when making this assessment that ten minutes in the summer sun is much more damaging than ten minutes at below zero temperatures. You will know by picking up the animal if the fur is slipping and the rotting process has gone too far to salvage.

If the above questions are satisfied, put the roadkill into a garbage bag, using latex gloves or a shovel. Some collectors like to coat the skins in salt if slippage is a concern (salt fights bacteria and dries out the skin, holding the hairs in place). If the animal is still warm, try to wrap it in newspaper until it cools down. Warm remains in a plastic bag can build up moisture and encourage slippage. Make a note of what animal you found and where you found it, along with the time and date. Double bag the roadkill and place it in a cooler (Coleman makes a nice seventy-quart one). A hacksaw and snippers are useful if only part of the roadkill is usable. Make sure to throw any remains that you do not take off the road—scavengers are put in danger when roadkill is left in busy streets. Once home, put your roadkill

NINE-BANDED ARMADILLO

Known by the Aztecs as turtle rabbits and during the Great Depression as Hoover Hogs, the nine-banded armadillo is native to the Americas, with an impressive range stretching from northern Argentina to the southern United States. Their protective shells, speed, and ability to dig make them relatively free of predators; however, their habit of jumping straight in the air when surprised makes them frequent roadkill, as they often collide with the undersides of cars when they might have been in the clear if they had stayed on the ground.

It might seem that armadillos would make the perfect fodder for taxidermy, since they are found littering southern American highways. But before you pick one up to bring home and pose with a banjo and curly mustache, be warned that armadillos can carry leprosy and can transmit the disease to humans through contact and consumption. While only about 5 percent of armadillos are passive carriers of leprosy and relatively few human transmissions have been documented, it is best to keep the armadillo on your no-touch roadkill list.

in the freezer to kill bacteria and parasites. Some taxidermists prefer to wrap their animals in nylon stockings instead of directly in plastic bags, again for slippage concerns. Label and date everything as clearly as you can *before* you put it in the freezer, and keep a list of what you have frozen so that you can find and identify the material when you have the right project.

A NOTE ON SAFETY: If you are collecting roadkill, remember that safety is key. The animal died because it was hit by a vehicle, and it is very possible that you are in danger of having the same thing happen to you. Practice extreme care and protect yourself during any collection. It is not a bad idea to invest in an orange safety vest and traffic cones. Never park or walk on a blind curve, and never stop if it seems unsafe. Limit yourself to animals on the banks of the road and collect only during the day.

NOTE ABOUT RAPTORS: Eagles, owls, and other birds of prey are heavily protected. If you find a sick or injured bird of prey, contact your nearest raptor center. If you find a dead one, contact the local wildlife department. *Do not* take it.

The Taxidermy Process

The process of taxidermy can be broken down into four basic steps: skinning, fleshing, preserving, and sewing onto a mount. Skinning the animal involves making a few precise incisions and carefully working muscles and bones from the skin while causing as little damage to the hide as possible. The process is not too different from dressing meat for food, except the end goal is to harvest the skin rather than the meat. After the hide has been separated from the body, it needs to be fleshed, removing as much tissue and fat as possible (again without cutting through the skin). The pelt is then treated to keep the specimen from rotting or being eaten by bugs. There are several preservation techniques that can be employed at this stage, including dry preserving (see page 182), wet and dry tanning, and brain tanning (see page 218), which are used to different effect on the hides. Finally, the pelt is sewn back together over a mount, ideally with enough skill

to hide the fact that there was a cut in the first place.

If you're interested in taking your practice a step further, there are many more taxidermy techniques that have been used and continue to be experimented with. One extreme example is an erosion casting technique used by British artist and taxidermist Emily Mayer. In erosion casting, you use a mold to capture the individual hairs on an animal. Once the rest of the carcass, including the skin, rots away, the mold is closed and filled with a resin. The end result, once the mold is removed, is a perfect cast of the animal with all of the hair embedded in the resin. Other techniques range from manipulating the skin during the drying process to encouraging slippage for furless mounts. Experimentation is happening all the time.

A FEW NOTES ON SAFETY: Always wear latex gloves when handling dead animals. They will reduce the risk of exposure to diseases and parasites. Make sure you are up-to-date on your immunizations, and if you cut yourself, see a doctor.

STUFFING

The idea that taxidermy mounts are "stuffed" comes from the early technique of filling a treated hide with cotton batting, sawdust, or rags. This rudimentary process resulted in preserved animals with poorly defined anatomy, uneven bulges, and lumpy faces. In an effort to better represent the aesthetic qualities of the living animal, taxidermists began to build forms. Since the modern process begins with a form, the process of stretching a skin and sewing it over the form is now called "mounting."

Study skins, which are preparations of (primarily bird) skins for scientific study, still get "stuffed" and resemble a lollipop when finished. Small mammals, like mice, can also be stuffed with cotton once cleaned and boraxed, because they require little articulation in their form. However, "stuffing" is seen as a derogatory term in the taxidermy community. The general rule is that a cook stuffs a turkey and a taxidermist mounts an animal.

A NOTE ON FORMS: There are several materials that can be used to create the frame or shape of a taxidermy animal. The most common today is a premade urethane foam armature, a lightweight, resilient, and long-lasting option that can be bought from a taxidermy store (see page 228) and altered to fit a specimen. (Learn more about working with a premade form on page 189.)

Wood wool, or excelsior, is a more traditional material. Wood wool is a slightly sticky wood shaving that is tightly bound with thread and wire to build up the shape of an animal and to give the form the ability to stand. Today it is more commonly used when working on smaller mammals and birds, although it can be used

with a wooden or wire frame for larger mammals. It is readily available in crafts stores and from taxidermy supply companies. (See page 205 for more information on working with wood wool.)

Documenting Your Work

Make sure to keep notes on each project as you go, including the animal source, mount or filling used, and your process. This will be an enormous help in determining what contributed to a successful or unsuccessful project. In addition to these notes, always take photographs of your work. There is a tendency to rush projects out the door to clients and galleries. But once the piece is gone, you will regret not having a photographic record. While most of us have access to a camera on our cell phones, it pays to invest in a proper camera and a backdrop so that your images are clean, focused, and large enough to print, if need be (or just make friends with a photographer who likes to photograph taxidermy). When taking photos (particularly if you're going to upload them to the Web), here are a few things to consider:

• **Choose carefully whether to photograph a piece on white, black, or in situ.** This will be determined in part by the color of the fur. Dark fur gets lost on a dark background without proper lighting, the same for white fur on a white background. A clean white background is generally preferred for mounts that will be posted online for sale.

• **Consider photographing some detail shots, in addition to the whole piece.** These close-up images will allow you to showcase your craftsmanship as well as create a more intimate perspective of the animal (think wildlife photos that are cropped to show just the animal's face, paws, or wings).

• **More is not always better.** Edit your images to those with the best angles and composition. You should overphotograph each piece, but try to limit the images you use to your best selects.

• **If your images are going to live on the Internet, add your name to the photographs.** That way, if it is shared, it will still lead back to

you. Whether you use a watermark or simply layer your name over the image, try to incorporate it so that it is not too much of a distraction, since many websites will just crop anything leading away from their site.

• **Select the order of your images** when presenting them on your own website or blog so that your audience gets the maximum effect of the piece. For example, you may want to "tease" the piece by starting out with a close-up, then a medium view, and finally a wide shot. Sequencing can make a huge difference in how people experience your work.

SQUIRREL LESSON

For the budding Rogue Taxidermist, nothing compares with a squirrel for your first taxidermy lesson. They are plentiful and considered nuisance animals in most urban spaces, so they are pretty readily available. In addition, they have more articulation than other common small mammals, like mice and guinea pigs.

The skin in this workshop has not been tanned, but rather dry preserved. Tanning a skin is recommended for larger animals.

WHAT YOU'LL NEED

PREP
- Squirrel carcass
- Latex gloves
- Paper towels
- Freezer bag or nylon stocking
- Pen or pencil
- Reference images

SKINNING
- Latex gloves
- Cardboard, newspaper, or butcher paper
- Ruler or tape measure
- Pen or pencil
- Scalpel with no. 22 blades
- Wire brush
- Borax*
- Clothespin or commercial tail stripper
- Fleshing beam (optional)
- Handheld beam (optional)
- Paintbrush (optional)
- Leather needle (circular or suture work well)
- 6-lb. fishing line or strong thread
- Dish detergent
- Bucket
- Hardwood sawdust or corncob grit

MOUNTING
- Premade manikin form
- Sandpaper
- Strong knife or Dremel tool (optional)
- Air-dry clay
- Woodworking tool or small, sharp screwdriver

- Glass eyes
- Scalpel
- Wire cutters
- Wire (16 gauge is good for a squirrel)
- Grinder or electrical tape
- Hide paste, Liquid Nails, or latex caulk (100 percent latex with no silicone)
- Pliers
- Leather needle (circular or suture work well)
- 6-lb. fishing line or strong thread
- Cotton (optional)
- Hairbrush
- Toothpick (optional)
- Insect or euro pins
- Card stock
- Paper clips
- Hair dryer
- Touch-up paint and paintbrush (optional)
- Accessories, such as a monocle/banjo/pork pie hat (optional)
- Base for mounting (premade, or make your own)

*Note: If you are planning on having a double feature and want to eat the animal you skinned, do not use borax. This is true also for meat that you plan to put out for animals or feed to pets. Any meat that borax touches needs to be disposed of. Also, do not use borax if you plan on tanning the skin, since borax raises the pH in the skin and will result in loss of hair.

PREP

1 Once you have a squirrel in hand, it is best to freeze the animal before work-
ing with it. This step will kill any insects and most parasites. Cold does not kill
all diseases, however, so make sure to always use latex gloves and wash your
hands carefully after any contact with the flesh. Roll the squirrel into a ball with
its tail on the outside. Wrap the squirrel in paper towels, which will help avoid
freezer burn. Then place it in a freezer bag. (If the animal is still warm, consider
storing it in a nylon stocking instead, since putting a warm critter in a plastic
bag can promote slippage.) Before putting the squirrel in the freezer, be sure
to label and date the bag—anything in the freezer can look the same, and you
wouldn't want to confuse a bag of blueberries with a squirrel carcass.

2 Collect reference images and, if possible, observe the animal in motion. If
you can't observe the animal in person, online videos can easily be found.
These observations will help you fill in the muscle variations. This step is all
the more important if you want to create a work of fiction—even if an animal is
imaginary, it must follow certain anatomical truths to trick the human eye.

3 When you are ready to work with the squirrel, take it out of the freezer and
defrost it in a cool area like the refrigerator. A cool sink will do the trick,
but make sure you don't let the squirrel sit too long, since it will begin to rot.
You may prefer to skin the squirrel before it totally defrosts, which reduces the
gore-factor and keeps the liquids from flowing.

4 Take a moment to inspect the squirrel. This is your chance to understand
this animal's particularities and any trauma that you might face. Without
trauma, the process can be almost bloodless; with trauma, a stronger stomach
is necessary. Pay special attention to the head and face, since you will want to
re-create their shape and balance.

SKINNING

1 When you're ready to begin skinning your squirrel, prepare a clutter-free space that is more than twice your animal's body length. Cover the work surface in cardboard, newspapers, or butcher paper. It might be best to figure out your music mix and turn off your phone—squirrel guts and borax can do wonders to electronics, especially those you put to your face.

2 Measure the squirrel's body from head to base of tail and around the widest part of the ribs. These measurements will help you pick the proper size form.

3 Being sure to locate any trauma to the skin or areas with fur loss, decide if you would like to position the squirrel stomach down (with its four paws on a branch, for instance), or stomach out (like it's reaching for a piece of pizza). Cut on the side that is least visible (so if the stomach is visible, make an incision on its back; if not, make an incision along the stomach).

4 Create a guide for your cut by parting the fur down the center of the body with a wire brush. Be careful to retain as much of the fur as you can, since this will hide the stitches.

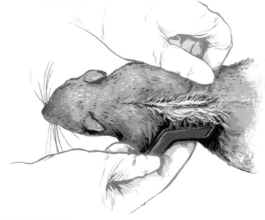

5 Begin to cut along this guide line, just deep enough to go through the skin, peeling the skin away from the carcass as you go and cutting any white lines (fascia) that appear between the skin and muscle. (This may seem vague, but once you start cutting you will see the division between the skin and muscle sack.)

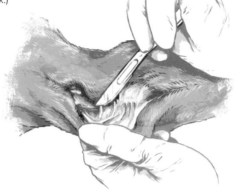

6 Sprinkle borax liberally as you cut to help dry the tissue and soak up any blood. Borax is inert, but that doesn't mean it won't sting if it gets in your eyes.

7 Once your cut is long enough to give you access to the legs, reach under the skin and work your hand around each limb. Invert each one by pushing it into the body and popping it out of the skin. (This move is called "taking off the pajamas.")

8 With a firm grip, continue to pull the limbs out of the skin until you reach the ankle joints.

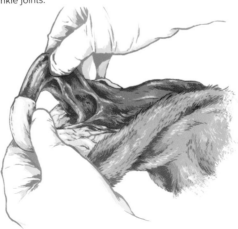

9 Cut the joints off as close to the paws as you can, freeing the legs from the skin but leaving the paws attached.

10 Once the body is free except for the tail, invert the base of the tail so that you can get a good hold. Using a clothespin or a commercial tail stripper, place the bone of the tail into the hollow part of the pin, and in one steady pull strip the tailbone and muscle out of the fur. It might take some practice to get this right. If your tail rips, don't worry—you can stitch or glue it back on at the end of the process.

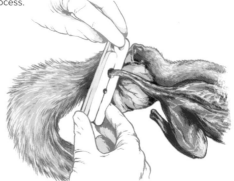

11 Once you get to the head, take your time. Using a scalpel, work the skin off of the head and neck. Be careful around the base of the ears. Cut as close to the skull as you can and make sure to keep the whole ear butt (the base of the ear that rests on the skull) attached to the skin.

12 Continue to cut as close to the skull as you can as you move toward the eye socket. Carefully cut the eyelid loose from the skull (beware—this skin is delicate). You want to get the entire eyelid and not cut any lashes. If you are careful, a finger pushed through the outside of the eye can guide you as you cut around the eyelids.

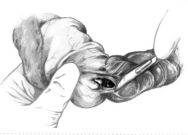

13 Continue to work your way down to the nose and cut through the cartilage so that the nose remains attached to the skin.

14 Continue to work down to the lips and cut them loose. The result should be a skin with paws and no skull attached.

15 Coat the inside of the skin thoroughly in borax and let it sit for half an hour.

16 At this point, the skin needs to be fleshed. Remove all remaining flesh using the scalpel and, if you'd like, a fleshing beam. The borax will help loosen the remaining fat and meat that you might have missed. Each foot should be fleshed and cleaned of any meat down to the toes. If your manikin form has foot pads, remove the foot bone on the skin, but retain the toes.

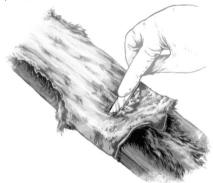

17 Next, the lip skin needs to be split so that you have a bit of skin to tuck into the lip slot you'll make on the manikin. Stretch the lip skin inside out, over the handheld beam (make sure the skin is taut) and split along the inside of the lip between the outer and inner layers with the scalpel, where the lip connects to the inside of the hide. This results in a flap that rolls into the mouth opening on top and bottom. This will also aid in helping the lip sit more naturally on the form.

18 Then you need to turn the ears inside out. There is a little pocket of flesh between the inner ear and the outer ear. With the skin inside out, use the scalpel to cut a small incision on the inside of the base of the ear. Using your finger or a paintbrush to push out or roll the ear open, cut to the end where the inner ear and outer ear skin meet. The result will be a pouch that will later be filled with clay to help the ears stand up properly.

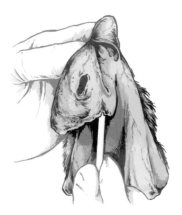

19 Sew up any holes that are in the skin.

20 Rinse off the borax under running water. Then wash the skin in dish detergent to degrease the skin as well as clean it. Repeat the rinse. Ring out any excess water.

21 Place the skin in a bucket with sawdust and shake back and forth for fifteen minutes or so. This helps to dry the skin and fur without applying any harsh heat. It also makes you buff.

22 At this point you have a damp and clean hide that is ready to mount.

MOUNTING

Now that you have a damp, soft hide, it is time to focus on the form you want to use. For this lesson, we will use a premade foam form. Commercial forms have a lot of advantages: They are relatively inexpensive, save you time, and come in common poses. While they look simple, these forms have come from molds made by skilled model makers. Nevertheless, there will be adjustments that need to be made. If there are significant changes to be made to your form, it is a smart idea to work on those adjustments before you skin your animal, since glues and clays will need to dry overnight.

Before you begin mounting, make sure that you have set aside time to finish the task. If the skin dries, it will be a challenge to rewet and pick up where you left off. If you need to stop for more than a few hours, put the project in a plastic bag and put it in the refrigerator.

1 When selecting your form, it is best to go a little small, since skins on live animals are not "tight." They have folds, wrinkles, and an overall look of lucidity. Choose a manikin that most closely relates to how you visualize your animal. Keep in mind that you can select mounts to accentuate or hide elements of your skin. For example, if your skin has hair loss on the stomach, choose a mount that places the stomach against the wall or a base.

2 Once you have selected a foam manikin, refer back to your measurements of the squirrel. You will most likely need to adjust your mount, by either adding to or subtracting from the form. If your foam form is too large, you can use sandpaper, a strong knife, or a Dremel to cut it down. Forms can easily be cut and then glued together to shorten. If your form is too small, you can use clay to build up specific areas or the overall mass.

3 The form will also benefit from a light sanding, which will help the hide paste adhere to the surface. When the manikins are cast, a seam forms along the mold line. This line should be sanded flat to avoid a ridge. Sand away any words or lettering on the form. If you are doing a lot of sanding, make sure to use a dust mask.

4 Test the fit of your skin over the form to identify what areas need further adjustment. And remember, it's always better to start with a form that is a bit too small than too big.

5 Using woodworking tools, or a sharp screw-driver, deepen the creases along the lips, nostrils, and mouth of the form to make a sufficient depression for your skin to tuck or fold into. This should be done anywhere else you need to tuck skin, such as under the arms and in the hip joint, depending on your form.

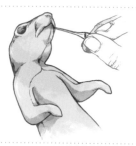

6 The forms are meant to be overly simple, so you will want to do some work on the face and head to create realism and give your creation character. Use air-dry clay to build up the lip ridge, brow, ear butts, nose, and eye sockets. The clay will remain soft, so you can further manipulate it once the skin is on the form.

7 Turning the head of your skin inside out, place a bit of clay into each ear fold. This will support the ear once it is attached with the clay onto the head of the form.

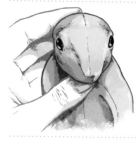

8 Place the glass eyes in the clay-filled eye sockets on the form. Unless you are going for the "Marty Feldman" look, the eyes should follow the line of the skull and sit equally on the sides. Check this by looking down the nose of the form and from the top.

9 Once the eyes are in place, use a thin roll of air-dry clay to build up the eyelids. These will be adjusted when the skin is on, but try to make it look as realistic as possible from the outset.

10 Next, hatch the skin along the inside of the whiskers. This will help the whiskers splay out properly.

11 Your form may have wires extending from the paws and feet. If your mount is sitting up and holding an object, you should keep these wires. If your mount is not holding anything and does not need the wire to connect to a base, cut the wire off. Either way, place a small bit of air-dry clay at the end of each paw and foot; this will allow you to adjust and position the feet better.

12 The form will not have a wire for the tail. Using the measurement of the squirrel's tailbone, cut a wire that is the length of the tail plus the thickness of the body, plus an additional two inches. Dull the end that will stick into the tail with a grinder, or simply place a small piece of electrical tape at the end.

13 Coat the wire in hide paste, Liquid Nails, or latex caulk and insert the tail. Use air-dry clay to replicate the muscle at the base. You will insert the wire into the mount once the skin has been placed. If the tail end breaks as you insert the wire, the tip can be glued on afterward.

14 Coat the form with hide paste (or whichever adhesive you're using), avoiding places where the skin will need to be sewn. Apply enough paste to be pushed around, but not so much that you have pockets of it. Now place the skin over the form, starting with the back paws.

JACKALOPE

Known to all as a symbol of the American West (and of uncles that make stuff up to confuse their nephews and nieces), the jackalope has the body of a jack rabbit and the horns of an antelope or buck deer. Legend has it that these horny rabbits or fighting bunnies have a taste for whiskey, can throw their voices to elude hunters, and can be milked for medicinal purposes.

First discovered in Wyoming by John Colter, a member of the Lewis and Clark expedition, the creature was also discovered in 1829, in Douglas, Wyoming. It was later thought up by Douglas Herrick during a hunting trip in 1932. Whichever story you prefer, the concept most likely originated from a medical condition called Shope papilloma virus, a cancer that affects rabbits and causes keratin tumors, which can resemble antlers or horns.

15 After the feet are positioned, insert the tail wire through the form, running from the position where the tail starts, through the stomach. If you have extra wire that extends through the form, fold it back toward the body with pliers and secure the wire, like a hook, into the form.

16 Once the tail has been positioned, any paw and foot wires should be run down the skin, along the bone, and out the paw and foot pad. Make sure your paws and feet are positioned to align with the form. Massage the skin on the legs and arms into a natural position.

17 With a thin strong thread, or fishing line, use the baseball stitch to sew the skin up. Start by making a knot at the top of your incision, then push the needle through the underside of the fur on one side and repeat on the other side, making small stitches and being careful not to catch any fur in the stitch, until finished.

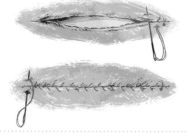

18 Check fur alignment as you go and work toward making a seam that is straight and clean. Brushing the hair out of the seam as you go helps. As you sew up your skin, look for areas that could use air-dry clay or cotton to add better form.

19 Once the skin is sewn up and massaged into place, focus on the head and face. Place a dot of air-dry clay into the nose. Push the clay up and out with a woodworking tool or small screwdriver until it comes out the nostrils. Remove excess.

20 Place two dots of air-dry clay into the whisker pockets on either side of the nose. Massage the cheeks and whiskers so that they rest naturally.

21 Using a small screwdriver or toothpick, tuck the lips into the depression you carved earlier. Start with the upper lip, beginning in the center and working out to the edges.

22 Tuck the lower lip into the same ridge under the upper lip. Use your reference images to create the proper mouth for your mount. Press the whiskers into the mound of clay. Use pins to hold the lips in place as the clay or glue dries.

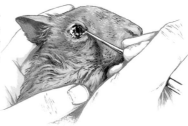

23 Using the toothpick or small screwdriver, work the eyelids around the glass eye. Simply tucking the edge under and into the clay should be enough. Use pins to hold the tear duct in place until dry.

24 Use your fingers to press the ears into the clay ear butts. At the same time, press the small dots of clay that you placed into the ear socket. This will spread out and fill the ear. Remove any excess that squeezes out.

25 Cut two pieces of card stock to the size and shape of the ears. Use small paper clips to hold the card stock and keep the ears in position. Keep the paper clips in place until the mount is dry. If they start to curl, work straight and reclip until dry.

26 Before you let the mount dry, give it a once-over. Make sure the skin falls naturally and is tucking into any folds in the form. Once dry, these adjustments won't be possible.

FINISHING

1 After three to five days, when the mount is completely dry, remove all pins and clips.

2 Brush out the hair, blowing out the tail and fur with a hair dryer set to cool.

3 Do any necessary touch-up painting on the nose.

4 If you'd like your mount to hold anything, like a miniature sextant or nunchuks, use the wires coming from the paws to attach it. Remove any excess wires.

5 Use the foot wires to connect the form to a base. This can easily be done by drilling through a piece of wood, inserting the wire, and securing it on the opposite side.

6 Now your squirrel has been mounted and you can focus on how to display your masterpiece or who will be the lucky recipient.

BIRD LESSON

Before selecting a bird for mounting, know that no matter how you acquired your specimen, many birds are just plain illegal to possess. A safe bet is to stick with farmed birds, nonmigratory birds that have hunting seasons, such as pheasants, gray partridge, and sage grouse, and birds that are not protected by the Migratory Bird Treaty Act, such as house sparrow, feral pigeon, and the common starling. For this workshop, we are using wood wool. Even though you can buy good forms for every size of bird, the wood wool will allow you to have more control, especially in early attempts. Plus wood wool is a lot more inexpensive and is easy to get.

WHAT YOU'LL NEED

PREP
- Bird carcass
- Latex gloves
- Cardboard
- Paper towels
- Plastic bag
- Pen or pencil
- Reference images
- Cotton

SKINNING
- Newspaper or butcher paper
- Latex gloves
- Spray bottle filled with water
- Scalpel with no. 22 blades
- Borax*
- Small, sharp scissors
- Small crochet hook (optional)
- Q-tips or spoon-shaped modeling tool

DEGREASING
- Bowls
- Dish detergent
- Latex gloves
- Large container with lid
- Hardwood sawdust or corncob grit
- Borax

MOUNTING
- Borax
- Air-dry clay
- 16-gauge wire (the gauge should be adjusted to support larger birds)
- Twine or string
- Grinder or electrical tape (optional)
- Cotton
- Wood wool
- Spray bottle filled with water
- 6-lb. fishing line or strong thread
- Commercial form or "backer rod" (optional, for neck)
- Pliers
- Glass eyes
- Woodworking tools
- Insect or euro pins
- Small needle (circular or suture work well)
- Base for mounting (premade, or make your own)
- Hair dryer
- Painter's tape or artist's tape (optional)
- Accessories (optional)

Note: If you want to eat the bird, do not use borax. Any meat that borax touches needs to be disposed of.

PREP

1. Once you have a bird in hand, it is best to freeze the animal first. This step will kill any insects and most parasites. Cold does not kill off all diseases, however, so make sure to always use latex gloves and wash your hands carefully after any contact with the flesh. Place cardboard on either side of the bird to keep the feathers from bending, and wrap the specimen with a paper towel. If the bird has extralong tail feathers, roll cardboard into a cone and place around the feather to add extra protection in the freezer. Put the bird in a plastic bag, and be sure to label and date the package.

2. Take some time to consider how you want your end mount to look. Collect reference images and, if possible, observe in real life how the bird looks standing, eating, flying, perching, and sitting down (this will help you fill in muscle variations). If this is not possible to do in person, consult online videos.

3. When you are ready to work with the bird, take it out of the freezer and defrost it in a cool area like the refrigerator. A cool sink will do the trick, but make sure you don't let the bird sit too long, since it will begin to rot. You may prefer to skin the bird before it defrosts, to reduce the amount of gore you'll encounter.

4. Work out the legs and torso to help separate the skin from the muscles before it has totally defrosted.

5. Take a moment to inspect the bird. This is your chance to understand this animal's particularities and any trauma that the bird might have faced. Place a piece of cotton into the beak and throat. This will keep fluids from surprising you while you are skinning the bird.

SKINNING

1. When you're ready to begin skinning your bird, prepare a clutter-free space. Cover the work surface with newspapers or butcher paper. Don't forget to wear latex gloves.

2. Birds have apteria, or skin without feathers, on their chest. Since feathers form in patterns and do not cover the whole surface, you can use this to your advantage. Locate the apteria, spray a little water on the chest, and part the feathers down the breast so that you can see the breastbone. The breastbone will be your incision guide.

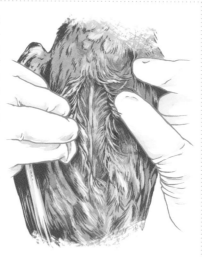

3. Make an incision down the chest, cutting a straight line from the breastbone to the crotch.

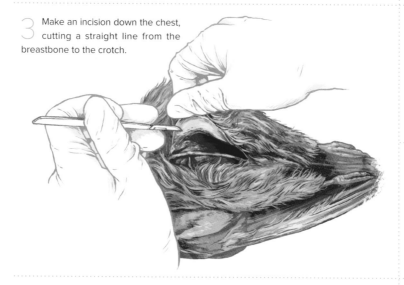

4 Use borax to free the skin from the muscle, since it works as a drying agent. This will also help keep blood and grease from getting on the feathers, which will make it easier to clean them later.

5 Carefully peel the skin away from the muscle and work your way down one of the bird's thighs. Once you have freed part of the leg, pop the knee out of the incision and work the skin off down to below the knee.

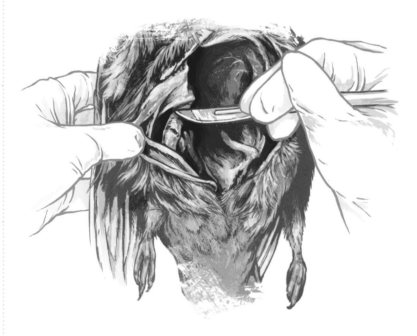

6 Cut the leg above the second joint with scissors or cutters. This will give you more flexibility when mounting later. Repeat with the other leg.

7 Now that the legs are free, work down around the tail. Cut the tailbone off, being careful to keep the tail feathers intact. Work up the back with your hands, being careful not to tear or cut the delicate back skin.

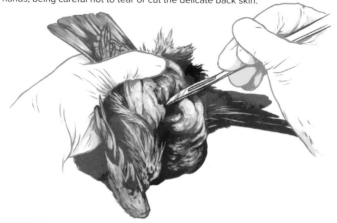

8 Cut through the breast muscle to sever the wings from the body; do this as close to the shoulder joints as you can.

9 Remove the body and torso from the inside of the skin. The neck, head, feet, and wings will remain attached to the skin.

10 It is a good idea to record the size of the body cavity once you've removed it, so that you can re-create these dimensions with a form, either foam or built up with wood wool. Outline the carcass of the bird onto your cardboard or butcher paper. Make an outline from the side and the top. Mark where the legs and wings came out of the body. Also note the length and thickness of the neck.

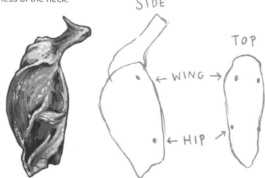

SIDE

TOP

← WING →

← HIP ↗

11 Flesh down the leg to the scales. (Think of fleshing the leg and wing like eating buffalo wings—you want to get all the meat.) With larger birds, you will need to remove the tendon in the foot (this is done by cutting into the foot pad and removing the tendon with a small crochet hook or hooked wire), but this is difficult and not necessary for a smaller bird.

12 The wing is a little more challenging, since some feather follicles go directly into the bone. As you pull the wing down to the flesh, you will see round indentations—these are the follicles. Take your time and be delicate so that you do not lose any wing feathers.

13 Leave the neck attached to the body while you pull the head inside out, then cut the neck at the atlas joint, or top vertebra, of the bird. Any bird whose head is about the same size as its neck can be pulled through. The neck skin does stretch a bit, on some birds more than others.

14 Invert the skin over the neck and head. Carefully loosen the skin from the skull. The first locking point you'll come to is where the ear skin is attached to the skull. Cut behind the ear hole to release the skin. Then do the eyes. Carefully pull the skin taut around the eyes in order to keep the eyelids intact on the skin.

15 Skin a little past the eyes and flesh the head. Keep the beak and skull attached to the skin.

16 Remove all meat in the skull, including the tongue and eyes, using borax to loosen the meat as you flesh. Use a small sharp pair of scissors and enlarge the brain hole cavity. Remove the brain (Q-tips work nicely, or a spoon-shaped modeling tool).

17. Using a scalpel, or borax and your fingers, make sure all of the flesh is removed from the entire bird—this will prevent rotting. (For larger birds, double check the tail area and remove the preen or oil gland, which is located in the tail.) This is delicate work. The smaller the bird, the more like tissue paper the skin is. It helps to keep the skin moist, since it will tear if it dries out.

DEGREASING

1. Once the skin is thoroughly fleshed, it needs to be cleaned. First, fill a bowl or sink with warm water and dish detergent.

2. Wash and scrub the flesh side of the bird in the water. This will loosen the grease and fat from the skin. Refresh the water and soap and soak the bird. Repeat this process until the water is clear.

3. Rinse the bird thoroughly in cool water to remove all of the detergent and fat. Wring out the skin carefully.

GRIP THE RAVEN

In the Rare Book Department of the Free Library of Philadelphia sits a piece of literary history: a black raven in a wooden case. "Grip, Drip, Grip-Grip the Clever, Grip the Wicked, Grip the Knowing," Grip the Raven was one of Charles Dickens's favorite pets—so much so that he had the creature mounted when Grip died, and even made him a minor character in *Barnaby Rudge*. Edgar Allan Poe, a literary reviewer in Philadelphia at the time of the book's publication, mentioned Grip in his review of the novel, and it's believed that Poe wrote "The Raven" with Grip in mind. Whether or not this is the case, Grip sits in Philadelphia as part of the Richard A. Gimbel Collection of Edgar Allan Poe.

4. Place the skin, feathers facing out, in a container with hardwood sawdust or corncob grit. Close the container and shake for five to ten minutes.

5. Remove from the hardwood sawdust and the skin should be drier. With smaller birds, it is best to keep the skin a little moist, so that it doesn't tear. Set the skin in a bowl of borax and work the borax in between the feathers (you can also put the skin in a bag with borax and shake to coat thoroughly).

6 If you are not able to begin mounting right away, put the clean skin in a bag and refrigerate, being sure to protect the long feathers. If it will be more than a day, freeze the skin.

MOUNTING

1 Now that the skin is finished being cleaned, you will want to fill the brain cavity with a dusting of borax and enough clay to complete the shape of the head.

2 Secure wires to the wings by running a wire along each wing bone. Bind the wire and bone with twine. Build up over the area where the wire and bone overlap, using cotton or wood wool wrapped with twine to replace the muscle you cut away earlier. The wire should extend away from the wing toward the center of the bird. It is helpful to dull the end that will face into the wing with a grinder or a small piece of electrical tape.

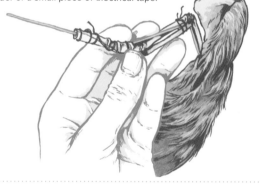

3 To wire the feet, find the channel that runs along the bone and under the scales. Push the wire down the channel between the bone and scales. Use the wire to guide some borax down the inside of the scales.

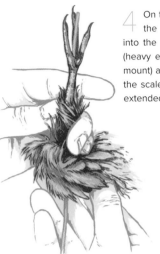

4 On the inside of the leg, bind the leg bone to the wire with string. The wire should extend into the body of the bird, like the wing wires do (heavy enough to support the bird's weight on a mount) and go down the length of the leg through the scale and out the middle digit. Leave enough extended to attach to your mount.

5 Use cotton to build out where the thighbone and wire overlap, but only as much as the muscle that you removed.

6 At this point, the skin will resemble a kite.

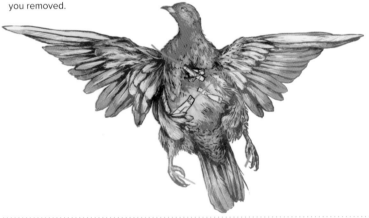

7 Now it's time to prepare your wood wool form. First, choose the shape of your mount. If your bird will be flying, you will need to prepare the form to hold the wings outstretched. If the bird is standing with wings folded, you will need to make grooves in your form that the wing can fold into.

8 Start with enough wood wool to make slightly half the girth of the bird's form. Moistening the wood wool with a spray bottle will help you be able to articulate the material.

9 Add more wood wool to fill in the breast area of the bird. Continue to compress and wrap with thread. Match the outline that you drew earlier on the cardboard or butcher paper. Make sure to lean to the smaller side, since it will be more difficult to stretch the skin over a larger form.

10 Use your drawings as reference to build up a neck form with wood wool. Attach this to the body form with a wire. Many taxidermists use commercial foam, or "backer rod," for the neck, since it comes in various sizes and can be cut easily.

11 Keep a wire exposed at the top of the neck. This will be inserted into the head of the bird.

12 Insert the form into the cavity of the skin, making sure to secure the neck wire into the clay-packed head.

13 Insert the wires of each wing diagonally through the body form, pull
them out the opposite side, and loop them back into the form. They
should ultimately exit the center of the form, below the breast.

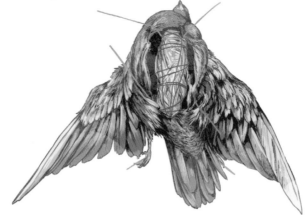

14 Using pliers, twist together the two wing wires that exited the chest. Trim
the excess and insert the points back into the form.

15 Repeat this process with leg
wires. Make sure to secure
the legs into the form so that it is
balanced. You will be able to adjust
the positioning of the legs and body
once it is attached to a base.

16 Insert a looped wire in the rear,
below the tail, to hold up any
tail feathers.

17 Place glass eyes into the clay-filled head.
Push the skin in and around the eyes with
the woodworking tool. Place a pin in the corner of
the eyes to hold the skin in place until it dries.

18 Sew up any holes in the skin. Then, sew the body up from the chest down to the tail, using a baseball stitch (see page 192). Be sure to adjust the feathers as you work so that they do not get caught in the stitch.

19 Choose your base or mount. Use the wire extending from the feet to secure the mount onto a display.

20 Go through the entire mount and manually adjust and fluff each feather. This will go a long way toward making the mount more life-like. A hair dryer set on low will help fluff up the bird as well.

21 If the wings are spread, pin some card stock to the wings until they dry in place. If the wings are resting against the bird's sides, tape or pin them to the body until dry. Painter's or artist's tape is also useful to secure the tail feathers into position while they dry.

22 Give the bird mount a week and a half to dry before taking out the pins, then add any accessories you wish.

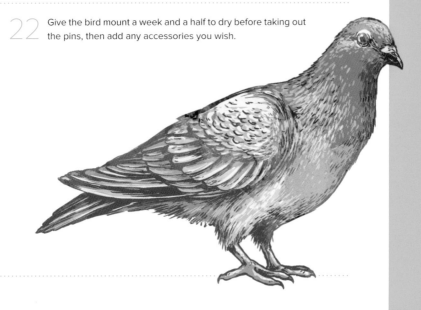

SKULL WHITENING

The biggest concern when working with bones (besides verifying that they are from an animal that is legal to collect) is making sure that all of the animal's flesh has been removed to prevent rot. When making taxidermy mounts, you flesh the skull and any bones you use. Borax is then placed on skins and bones to help dry up any remaining flesh that you might have missed. But for the best control over the process, nothing can beat harnessing a dermestid beetle (*Dermestes maculate*) colony. These bugs love dead flesh but are harmless to living skin. The life span of the dermestid beetle is about four months. After the eggs are laid, they hatch in a matter of days, and the larvae are incredibly hungry when they emerge (molting six to nine times and growing to the size of the head of a pin). After a month, they burrow in order to enter into a pupal state for a week. After this time, they emerge as beetles. Females are larger and will lay eggs after about two months, continuing to lay eggs every five days for their remaining life span.

Beware that dermestids also love taxidermy collections and can expand their taste to old books, carpets, and record covers. So keep your colony away from your collection and make efforts to secure the colony.

WHAT YOU'LL NEED

- 75-gallon tank at least 20 inches tall*
- Mesh screen liner
- Box fan
- Paper towels or substrate
- Egg crates, cotton batting, or cardboard
- Dermestid beetle colony
- Small animal carcasses, bone scraps, or pig ears
- Latex gloves
- Partially fleshed skull
- Pot
- Borax or sodium carbonate
- Wire brush
- Garden hose (optional)
- Dish detergent
- Lacquer thinner (optional)
- Bowl
- Climber's chalk, quick white, or baking soda
- Volume 40 hydrogen peroxide
- Toothbrush or small paintbrush
- White primer or clear lacquer (optional)

Note: If using a fish tank, remove the corner silicon strips, which help the beetles climb up and escape.

PREP

1 Cut a mesh screen to the dimensions of your tank or container. Place the fan over the screen so that it vents outward to help minimize the smell of rotting flesh.

2 Add a layer of towels to the bottom of the container. Place a second layer of barely moist towel on top of the first layer. (This provides water for the beetles to drink.)

3 Add the egg crates, cotton batting, or cardboard at one end of the tank to give the beetles a safe place to grow into the pupal stage.

4 Since the colony will be eating gross dead stuff and pooping, the smell can be pretty fierce. If the fan does not help, it is wise to keep the colony away from your living space.

5 Wherever you keep the tank, be sure that it stays dry and warm. The biggest threat to beetles is mold and too much moisture. Keep the tank or container around room temperature, between 65°F and 80°F (at 85°F the beetles develop the ability to fly, which is not what you want). This helps the colony stay healthy.

6 Add your beetles to the tank. When looking for a seed colony of beetles, you want dermestids at different stages of their life cycle: different-size larvae, pupae, and adults.

7 You may have to grow your colony by feeding it, since a few hundred can flesh a small mammal, but you will need thousands to flesh larger skulls, such as those of a bear or deer. Grow your colony with skulls from smaller animals, bone scraps from a local butcher, or pig ears (which are easy to get from pet stores).

FLESHING

Once the colony has been comfortably eating the small bones and pig ears, put on latex gloves and place your partially fleshed skull next to the "pupation area." This allows the beetles to feed and retreat to safety. A partially fleshed skull works best with the beetles, since too much flesh will take longer for them to clean and will smell much worse. A healthy colony can flesh a deer skull in a day or two. Once this is done, continue to feed the colony daily. See page 213 for more on beetle colony care.

DEGREASING

1 Now that the beetles have gotten most of the flesh off the skull, it is time to get rid of the excess oil and fat that is in the skull itself. Put it into a pot with a borax and water to cover (one gallon of water to a half cup of borax); you can substitute sodium carbonate for borax here.

2 Heat the water to 180°F for twenty to thirty minutes, depending on the size of the skull. Do not hard boil. It is also important that you do not boil it too long, since that will split the lower jaw in half, loosen the teeth, and possibly compromise the zygomatic arch (the cheekbone). If any of this does break, you can glue pieces back together at the end.

3 Remove the skull and let it cool. Once you can hold the piece, peel or cut off any remaining meat. You can use a wire brush to really clean off the bone. Run a garden hose, or high-pressure water, into the skull cavity to wash out any of the mush.

4 Scrub the skull with liquid detergent and soak in a mixture of the detergent and water.

5 For very greasy skulls, like a bird skull, you can rinse with lacquer thinner as an additional cleaning step.

THE CYCLOPS SKULL

Bones, especially skulls, have always been a part of collections—from cabinets of curiosities to modern-day natural history museums. And depending on the knowledge of the day, these artifacts were sometimes misappropriated and said to have come from creatures we now know never existed. Pliny the Elder mentions having seen bones of hippocentaurs that were discovered in Egypt. Remains of griffins were seen by ancient Scythians and taken as evidence that gold was to be found nearby (according to myth, these creatures guarded deposits of this precious mineral). Even Thomas Jefferson used the bones of the great megalonyx to prove that giant animals still roamed the unexplored Americas. To this day, one can find elephant skulls in modern-day natural history museums identified as "Cyclops Skulls." (This last misappropriation, though perhaps innocent at first, was happily perpetuated by the master humbug P. T. Barnum, much to the benefit of his American Museum—see page 20.)

These monsters (and others like them) have played a vital role in natural history and the arts. They provided a way for educated people to explain things that were unexplainable at the time and fueled the creative instincts of artists from Hieronymus Bosch to Salvador Dalí.

WHITENING

1 Now that the skull is cleaned, it is ready to be whitened. Put one cup of common climber's chalk, quick white, or baking soda in a large bowl. Add some volume 40 hydrogen peroxide and mix. You want to reach a consistency like a milk shake or mayonnaise, so add more peroxide as needed and continue to mix. Remember to wear gloves.

2 Using a toothbrush or small paintbrush, coat the skull with the mixture. Make sure to get every part. If you prefer for the teeth to remain a little yellowed and natural-looking, do not coat with the mixture.

3 Let sit for about two days. During this time the mixture will turn to a powder.

4 Rinse off with water or brush clean.

5 You may want to enhance the white of the bone by lightly coating the skull in white primer or with a clear lacquer. But this is not necessary.

A NOTE ON BEETLE COLONY CARE:
At some point, the colony will smell bad due to a build-up of frass (beetle poop) and you will want to change the substrate and move the beetles. The best way is to build a Berlese funnel or Berlese trap. Instructions for building one are easily available online. A Berlese trap is built out of a sieve-covered funnel, with a lightbulb above and a collecting jar below. In order to keep away from the heat of the bulb, the beetles work their way down the funnel through the sieve and into the attached container that houses a bit of clean substrate. The bulb is left on overnight to ensure that all of the beetles have left the dirty substrate. Discard the dirty substrate outdoors, in case you missed any beetles. Make sure to transfer any cotton batting or cardboard that might contain eggs into the new substrate.

A properly cared-for colony can last for years and proves useful when making friends with hunters in need of fleshing services.

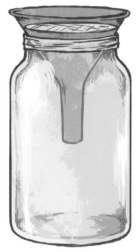

WET PRESERVATION

Wet preservations were a part of large and small collections long before the development of traditional taxidermy. The process is very simple, and the materials needed are readily accessible. As with the other workshops, through practice you will be able to make the process your own.

A NOTE ON ALCOHOL DILUTIONS: Alcohol used in wet preservation is called ethyl alcohol and is typically sold at 95 percent dilution. There is a formula for creating lower dilutions, but it gets complex quickly. The easiest way is to decide the dilution you would like, say 70 percent. Then take 70 ml of 95 percent alcohol and add 25 ml of water to a total of a 95 ml solution. This will result in 70 percent dilution alcohol. To get a 50 percent dilution, take 50 ml of 95 percent alcohol and add 95 ml of water.

WHAT YOU'LL NEED

- Specimen
- Glass or acrylic container that is leak-proof
- Latex gloves
- Safety glasses
- Respirator
- Formalin (10 percent buffered)
- Syringe or scalpel
- A prep container (roughly the same size as your final container)
- Alcohol
- Pen or pencil

PREP

1 Choose your specimen. Small mammals, fish, and animal fetuses are readily
available through science supply companies. Roadkill can also be preserved
this way. Remember, the same laws that apply to taxidermy apply here as well.

2 Choose your container. It should be
glass or acrylic and taller than the
specimen. Make sure the container is
leak-proof and can be sealed. Nothing
can lose your rental deposit faster than
wet specimen spillage.

3 The quality of the preservation
depends on the freshness of the ani-
mal, so if you are not able to begin right
away, freeze your specimen until you are
ready. Make sure to fully defrost the ani-
mal before preserving.

PRESERVING

1 Use care when handling both alco-
hol and formalin. Latex gloves, safety
glasses, and a respirator should be worn
while using formalin. Both are toxic and
cause irritation to the skin, nose, and
throat.

THE PHYSICAL IMPOSSIBILITY OF DEATH IN THE MIND OF SOMEONE LIVING

While studying art at Goldsmiths, Uni-
versity of London in 1989, Damien Hirst
conceived of preserving a shark in a tank to
express the challenge of contemplating death,
an artwork that would later assume the elegant
title *The Physical Impossibility of Death in the
Mind of Someone Living*. Charles Saatchi agreed
to finance the piece, which included the hunting
of the shark, its transportation from Australia to
England, its preservation, and the construction
of a glass and steel tank. Unfortunately, after this
tremendous amount of work, the first shark dete-
riorated due to inferior preservation techniques.
When Saatchi sold the piece to Steven Cohen in
2004, Hirst offered to replace the piece, hunting
a second shark, transporting it, and using a more
comprehensive technique to preserve the shark.
The piece's significance is due in part to the fact
that it is the best known "Darrin Stephens moment"
in contemporary art—the "protagonist" has been
completely replaced without affecting the value or
meaning of the work. More than twenty years later,
it remains a signpost in the world of bio art.

2 To harden the specimen's soft tissue, place the specimen in your container
and soak it so that it is completely immersed in 10 percent formalin for one
week. A good ratio to make sure the specimen is covered properly is a 1:12
tissue-to-formalin mixture (by size).

3 For frogs, which have pockets of air, or larger animals, like pigs, simply being soaked in formalin will not sufficiently penetrate the body cavity and will result in rotting. Instead, the 10 percent formalin should also be injected into the body cavity, and you should inject the outside of the specimen in a grid at regular intervals. You can also use a scalpel to make very small incisions all over the body, giving the formalin more surface area to penetrate.

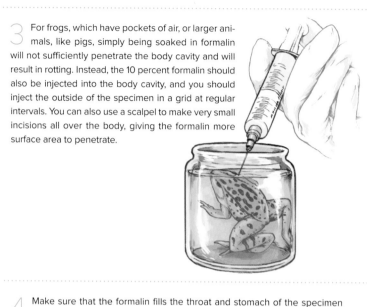

4 Make sure that the formalin fills the throat and stomach of the specimen when soaking. The idea is to get as much saturation as possible.

5 After a week of soaking in formalin, remove your specimen and rinse in running water for five minutes. To further rinse out the formalin, put it in a prepping container and let it soak in water for one day to leach out the remaining formalin.

6 Once the specimen has been rinsed, place it in your final container along with a dilution of 50 percent alcohol for thirty minutes. Dump out the 50 percent dilution (you can save this for other specimens as long as it is not cloudy).

7 Fill the container with a 70 percent alcohol solution for twenty-four hours.

8 Dump out the 70 percent dilution and replace with 80 percent alcohol dilution for long-term storage. (A dilution of less than 70 percent will allow the specimen to rot.)

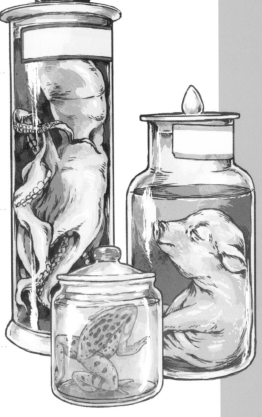

9 If you suspect you may want to remove the specimen at any time, make sure that it is placed into the container in such a way that when it hardens, you can still get it to come out.

10 Seal up your contain and label the contents, date of preservation, and percentage of alcohol. All of this may be of interest to you or someone else in the future.

BRAIN TANNING

For this lesson we will explore brain tanning with mammals. This is a very simple process, which like all simple things, is quite difficult and requires patience and practice. We will be using the actual brains of the animal in combination with smoke to preserve the skin, resulting in a soft and supple material. This method of tanning introduces emulsified brain oils into the hide, while the tar in the smoke traps the oils. If you have a roadkill animal that does not have brains to work with, they can be easily purchased from a butcher. Brains can be frozen and will work well once defrosted. Egg yolks can be used as a substitute (a dozen egg yolks to a gallon of water). In areas prone to CWD (chronic wasting disease), it is not a good idea to interact with the brain of deer. As with other lessons, gloves are recommended.

WHAT YOU'LL NEED

DAY 1 PREP

- Animal carcass
- Latex gloves
- Scalpel with no. 22 blades
- Container (for storing skull)
- Fleshing beam (optional)
- Frame and insect or euro pins (for small hide) or stakes (for large hide)

TANNING

- Wire (optional)
- Small, sealed container (optional)
- Pot
- Rag (optional)
- Twine or string

DAY 2 PREP

- Light-grit sandpaper (optional)

SMOKING

- Insect or euro pins, clothespins, or leather needle and strong thread
- Punky, wettish wood

FINISHING

- Topical soap
- Hair dryer (optional)
- Broom
- Leather conditioning oil

DAY 1 PREP

1 Skin your animal and wash the hide as described in "Squirrel Lesson" (pages 184–188). Make sure not to cut into the skin—the fewer holes, the better when smoking.

2 Save the animal's skull. It should be kept in a cool place, such as the refrigerator. Like all gross stuff in a fridge, make sure to label the skull or brains well. The fewer surprises the better.

3 Stretch the hide. If you're working with a small hide, like a squirrel's, it can be pinned to a simple frame. For a larger hide, pierce the skin with string or thread and stake it into the ground. Either way, make sure the hide is taut.

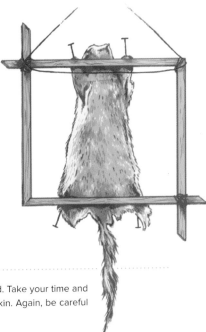

4 Now the hide is ready to be fleshed. Take your time and get all of the flesh and fat off the skin. Again, be careful not to cut through the hide

TANNING

1 At this point, you want to prepare your "brain soup." If you want to retain the skull for use in another project, you will have to be creative in scraping out the brain through the neck opening or through the nose. You can use a thin wire with a loop at the end to mash the brain and remove it. This takes some time and is slow going, since the brain is sticky.

2 Mash the brain into a paste. You can also shake the pieces up in a sealed container to really break up the brain matter. Then mix in some water to extend the brain soup. For a squirrel brain, you should use half a cup of water. For a deer brain, use around half a gallon of water.

3 Pour the "brain soup" into a pot and bring it to a light boil. Then let it cool. This will change the color from a high pink to a dull gray.

4 Once cool, rub the "brain soup" on the flesh side of the hide only. You want to make sure the flesh side soaks up as much of the soup as it can. One way to aid this is to soak a rag in the "brain soup," place it along the flesh side, and roll up the hide, securing it with thread or twine. Store overnight. If you prefer to just have the buckskin, you can soak the hide in the solution overnight, then scrape the hide by running a dull long blade or tool over the fur side to remove the follicles.

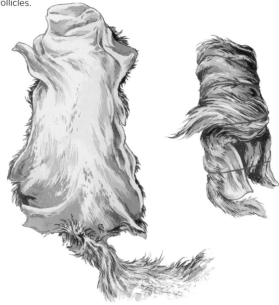

DAY 2 PREP

1 Build a fire. It needs to get very hot, and stay that way, so that when the punky wood is added (Smoking, Step 2) the fire doesn't go out. Keep stoking the fire as you prepare the hide.

2 The next step is to get as much of the moisture out of the hide as possible. Unroll, if you used the rag method, and wring out as much of the solution as you can.

3 Reattach the hide to your frame.

4 Let the hide dry while stretched out, taking it off the frame and working it occasionally. It must dry completely for the next step to work properly.

5 At this point, your hide should be very soft. If there are rough sections, brush out these spots with a light-grit sandpaper.

SMOKING

1 Make a sock out of the pelt, with the fur on the outside. This way you can capture as much smoke in the pelt as you can. To make this sock you can pin, clip, or sew the pelt together.

2 When your hide is ready, add punky, wettish wood to the fire. This will cool it a bit and create a smoky fire.

3 Suspend the "sock" over the fire. Funnel the smoke into the sock of the pelt without getting the hide too close to the fire. Here, an a-frame holds the skin open to catch as much smoke as possible. Be careful that your hide is not directly over the fire, or else you will risk making squirrel bacon. (Okay, not actually bacon, but that is what the burnt hide will resemble.)

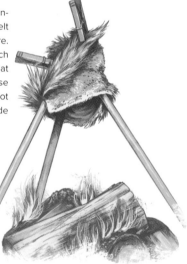

4 Keep a steady stream of smoke on the hide. Be careful of sparks that might burn your hide. For a smaller hide, like a squirrel or rabbit, thirty to sixty minutes will be plenty of time. For larger pelts, smoke for an hour, but make sure to rotate the skins to smoke evenly. The flesh side will change color as the smoke passes through. This should be more tan than white. If it starts to turn bacon colored, your fire is too hot or your hide is too close to the heat.

FINISHING

1 At this point, the skin will be hard, so you will need to break it. Wash the fur in topical soap to clean and massage the skin. Blow dry or let hang until dry.

2 Once dry, stretch and work the skin over a broom handle until it feels like suede. This will take a good amount of time; be patient and keep working the hide.

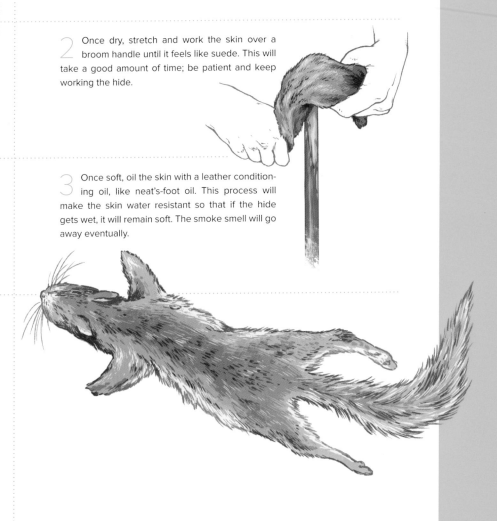

3 Once soft, oil the skin with a leather conditioning oil, like neat's-foot oil. This process will make the skin water resistant so that if the hide gets wet, it will remain soft. The smoke smell will go away eventually.

FURTHER READING

ONLINE RESOURCES

Atlas Obscura
www.atlasobscura.com
A collaborative website that highlights obscure and wonderful places, including museum collections, specifically created to help the global community share local treasures. It is a great resource if you're hoping to locate curiosities when traveling.

Breakthrough
www.breakthroughmagazine.com
The leading magazine in the field of taxidermy, as well as a supplier of taxidermy manuals.

Minnesota Association of Rogue Taxidermists
www.roguetaxidermy.com
The only international organization dedicated to Rogue Taxidermy and taxidermy art.

Morbid Anatomy
www.morbidanatomy.blogspot.com
A blog devoted to the "interstices of art and medicine, death and culture."

Preserved!
www.preservedproject.co.uk
This blog stemmed from the Culture of Preservation conference, held from 2010 to 2012 in London, and continues to publish articles about the cultural and political significance of preserved animals.

Ravishing Beasts Taxidermy
www.ravishingbeasts.com
Rachel Poliquin's blog devoted to taxidermy as the aesthetic side of natural history.

Taxidermy.net
This website is the main resource for traditional taxidermists. Its forums are a great place to ask questions of experienced taxidermists, but be warned, the users do not always appreciate nontraditional approaches.

Taxidermy in Art
www.taxidermy-in-art.tumblr.com
A French Tumblr account that catalogs taxidermy in contemporary and Modern art.

BOOKS ON TAXIDERMY

The Art of Taxidermy, Jane Eastoe

The Authentic Animal, Dave Madden

The Breathless Zoo: Taxidermy and the Cultures of Longing, Rachel Poliquin

A History of Taxidermy: Art, Science and Bad Taste, P. A. Morris

Home Book of Taxidermy and Tanning, Gerald J. Grantz

The Sportsman's Handbook to Collecting, Preserving, and Setting Up Trophies and Specimens, Rowland Ward

Still Life: Adventures in Taxidermy, Melissa Milgrom

Taxidermy, Alexis Turner

Taxidermy Guide, Russell Tinsley

Taxidermy Step by Step, Waddy F. McFall

Walter Potter and His Museum of Curious Taxidermy, Pat Morris and Joanna Ebenstein

BOOKS ON NATURAL HISTORY

The Artificial Kingdom: On the Kitsch Experience, Celeste Olalquiaga

The Book of Imaginary Beings, Jorge Luis Borges

Cabinets of Curiosities, Patrick Mauriès

Carnivorous Nights: On the Trail of the Tasmanian Tiger, Margarte Mittelbach and Michael Crewdson

Concrete Jungle, Mark Dion and Alexis Rockman

"The Demise of Trophies: A Short History of Taxidermied Animals in Art" (essay in the exhibition catalog *Furniture as Trophy*, Austrian Museum of Applied Arts)

The Discoverers: A History of Man's Search to Know His World and Himself, Daniel J. Boorstin

Kingdom Under Glass: A Tale of Obsession, Adventure, and One Man's Quest to Preserve the World's Great Animals, Jay Kirk

Martha Maxwell: Rocky Mountain Naturalist, Maxine Benson

Omnivore's Dilemma: A Natural History of Four Meals, Michael Pollan

On Monsters: An Unnatural History of Our Worst Fears, Stephen T. Asma

Stuffed Animals and Pickled Heads: The Culture and Evolution of Natural History Museums, Stephen T. Asma

The Urban Naturalist, Steven D. Garber

BOOKS ON ART

Artist/Animal, Steve Baker

Cabinet of Curiosities: Mark Dion and the University as Installation, Colleen J. Sheehy

Curiosity and Method: Ten Years of Cabinet *Magazine*, edited by Sira Najafi

Everything That Creeps, Elizabeth McGrath

Finders, Keepers: Eight Collectors, Rosamond Wolff Purcell and Stephen Jay Gould

A Gap in Nature: Discovering the World's Extinct Animals, Tim Flannery and Peter Schouten

Handmade Nation: The Rise of DIY, Art, Craft, and Design, Faythe Levine and Cortney Heimerl

Incurable Disorder: The Art of Elizabeth McGrath, Elizabeth McGrath

Mark Dion, Phaidon

Mark Dion: The Natural History of the Museum, Archibooks

Méret Oppenheim: Beyond the Teacup, Jacqueline Burckhardt

Mr. Wilson's Cabinet of Wonder: Pronged Ants, Horned Humans, Mice on Toast, and Other Marvels of Jurassic Technology, Lawrence Weschler

1000 Degrees Celsius Deyrolle, Laurent Bochet

Strange Nature, Jessica Joslin

Trout of the World, James Prosek

The Work of Art in the Age of Its Technological Reproducibility and Other Writings on Media, Walter Benjamin

ARTISTS FEATURED IN THIS BOOK

Scott Bibus
www.deadanimalart.com

Lisa Black
www.lisablackcreations.com

Sarina Brewer
www.chimerataxidermyarts.com

Kate Clark
www.kateclark.com

Julia DeVille
www.juliadeville.com

Tessa Farmer
www.tessafarmer.com

Peter Gronquist
www.petergronquist.com

Nate Hill
www.natehillisnuts.com

The Idiots
www.idiots.nl

Kate Innamorato
www.afterlifeanatomy.com

Jessica Joslin
www.jessicajoslin.com

Les Deux Garçons
www.lesdeuxgarcons.nl

Robert Marbury
www.robertmarbury.com

Elizabeth McGrath
www.elizabethmcgrath.com

Rod McRae
www.rodmcrae.com.au

Claire Morgan
www.claire-morgan.co.uk

Polly Morgan
www.pollymorgan.co.uk

James Prosek
www.jamesprosek.com

Iris Schieferstein
www.iris-schieferstein.de

Mirmy Winn
www.mirmy.com

Mark Dion does not have a website.

PLACES TO VISIT

ODDITY SHOPS

Bazaar
Baltimore, MD
www.bazaarbaltimore.com
This newcomer brings all the oddities that the already odd Baltimore neighborhood of Hampden has been lacking. Schedules taxidermy classes.

The Belfry
Seattle, WA
www.thebelfryoddities.com
The stop in Seattle for the mysteriously beautiful and intriguingly macabre. Schedules taxidermy classes.

Decoratus Curious Antiques and Oddities
West Chester, PA
www.decoratuscurious.wordpress.com
A celebration of the beautifully weird in suburban Philadelphia. Schedules taxidermy classes.

Deyrolle
Paris, France
www.deyrolle.com
Opened in 1832, this cabinet of curiosities suffered a serious fire in 2008. The reopened shop is an essential stop in Paris for natural history and taxidermy.

The Evolution Store
New York, NY
www.theevolutionstore.com
A paradise for the collector of science and natural history, in the heart of New York City's SoHo neighborhood.

Loved to Death
San Francisco, CA
www.lovedtodeath.com
Started as a taxidermy art project but blossomed into a storefront on Haight.

Necromance
Los Angeles, CA
www.necromance.com
Holding down the oddities scene on Melrose since 1991.

Obscura Antiques and Oddities
New York, NY
www.obscuraantiques.com
Making the East Village more curious with medical antiques, taxidermy, and well-curated odd objects. Obscura was made famous through its long-running cable television series.

Pandora's Box
Milford, MA
www.pandorasboxoddities.com
A small store packed with custom Beauchene skulls and diaphonized specimens. Custom orders welcome. Schedules taxidermy classes.

Paxton Gate
San Francisco, CA
www.paxtongate.com
Started in 1992 as a natural science and gardening store, the shop soon began to specialize in the bizarre. Schedules taxidermy classes.

Paxton Gate PDX
Portland, OR
www.paxtongatepdx.com
While named after the San Francisco store, Portland's Paxton Gate is locally owned and features the best of the Pacific Northwest. Schedules taxidermy classes.

Woolly Mammoth Antiques & Oddities
Chicago, IL
www.woollymammothchicago.com
A cabinet of curiosities in the heart of Chicago's Andersonville. Schedules taxidermy classes.

MUSEUMS

The Academy of Natural Sciences of Drexel University
Philadelphia, PA
www.ansp.org
Founded in 1912, this is the oldest natural history museum in the New World and houses the Titian Peale Butterfly and Moth collection.

The American Museum of Natural History
New York, NY
www.amnh.org
The country's most famous taxidermists and artists, from Carl Akeley to David Schwendeman, came together to create these elaborate halls of habitat dioramas. AMNH also has an incredible online digital resource library of taxidermy and diorama images.

The Bell Museum of Natural History
Minneapolis, MN
www.bellmuseum.umn.edu
Located on the University of Minnesota's campus, this small Art Deco building houses some of the best diorama paintings of Francis Lee Jaques.

The California Academy of Sciences
San Francisco, CA
www.calacademy.org
The academy's famous African Hall was created in 1934 under the partnership of hunter Leslie Simson and taxidermist Frank Tose, along with work by the famous Jonas brothers. The newly named Tusher African Hall, which opened in 2008, is a re-creation of the original hall in a new building.

The Carnegie Museum of Natural History
Pittsburgh, PA
www.carnegiemnh.org
One of the four Carnegie museums of Pittsburgh, the CMNH is a research museum and home to French taxidermist Jules Verrezux's *Arab Courier Attacked by Lions,* which was made for the 1867 Paris Exposition and features two Barbary lions attacking a manikin riding a camel.

The Denver Museum of Nature & Science
Denver, CO
www.dmns.org
Started in 1900 by naturalist Edwin Carter, this museum is dedicated to Colorado birds, mammals, and fauna.

The Field Museum of Natural History
Chicago, IL
www.fieldmuseum.org
Home of the Tsavo man-eaters and Su Lin, the first panda taken out of China, as well as Carl Akeley's "Four Seasons" diorama series.

The LA County Museum of Natural History
Los Angeles, CA
www.nhm.org
Part of the Natural History Family of Museums in Los Angeles, along with the Hart Museum and the Page Museum at the La Brea Tar Pits. The Natural History Museum has a taxidermy department on staff so that dioramas continue to get updated.

The Milwaukee Public Museum
Milwaukee, WI
www.mpm.edu
Opened in 1884, this museum is home to Carl Akeley's muskrat diorama, the first diorama created in a museum.

Morbid Anatomy Museum
Brooklyn, NY
www.morbidanatomymuseum.org
A new museum in the Gowanus neighborhood of Brooklyn, presenting the artifacts and ideas that fall through the cracks.

The Museum of Jurassic Technology
Los Angeles, CA
www.mjt.org
Started in 1988 by David Hildebrand Wilson and Diana Drake Wilson, this is the greatest contemporary cabinet of wonders in the United States.

Mütter Museum
Philadelphia, PA
www.collegeofphysicians.org/mutter-museum
Started with an 1858 collection of anatomical specimens, medical instruments, and human oddities from Dr. Thomas Dent Mütter, this museum continues the nineteenth-century cabinet tradition.

Smithsonian National Museum of Natural History
Washington, DC
www.mnh.si.edu
A supergroup of contemporary taxidermists were brought together to create the mounts for the opening of the more interactive Kenneth E. Behring Family Hall of Mammals in 2003, which replaced the museum's original taxidermy diorama displays.

University of Kansas, Natural History Museum
Lawrence, KS
www.naturalhistory.ku.edu
The Panorama hall includes taxidermy mounts originally prepared by taxidermist Lewis Lindsay Dyche for the official Kansas Pavilion at the 1893 World's Columbian Exposition in Chicago.

The Viktor Wynd Museum of Curiosities
London, United Kingdom
www.viktorwyndofhackney.co.uk
A must visit in London's Hackney neighborhood, with taxidermy classes, lecture series, and a basement full of wonders.

Walters Art Museum
Baltimore, MD
www.thewalters.org
The Walters is a traditional museum dedicated to art from antiquity to the twentieth century, but it houses the Chamber of Wonders, an example of a late-renaissance *Wonderkammer.*

The Yale Peabody Museum of Natural History
New Haven, CT
www.peabody.yale.edu
One of the oldest natural history museums in the United States. Be sure to look for the diorama paintings by James Perry Wilson and by Francis Lee Jacques.

SUPPLIES

Carolina
www.carolina.com
For lab supplies and equipment like scalpels, blades, and pins.

Craigslist.com
It is good to keep an eye on this site for local resources and unique sales.

eBay.com
This is a great place to find skins and older taxidermy mounts. Remember that eBay is not responsible for the legality of these auctions, so be sure to verify that an item is legal to possess in your state before you bid.

Ellzey's Squirrel Forms
www.ellzeys.com
Specializing in squirrel forms.

Jim Allred Taxidermy Supply
www.jimallred.com
Taxidermy supplies with an online seconds and reject section.

McKenzie Taxidermy Supplies
www.mckenziesp.com
The largest supplier of taxidermy forms and materials in the United States.

Monsterfeeders
www.monsterfeeders.com
For feeder animals, like piglets and rats, which are traditionally sold as food for pet snakes, reptiles, and exotics.

Research Mannikins
www.rmi-online.com
Great sales on taxidermy forms and supplies. A list of damaged taxidermy forms for sale is available if you contact them.

Rodent Pro
www.rodentpro.com
For feeder animals, like mice, rats, rabbits, guinea pigs, chickens, and quail.

Save on Crafts
www.save-on-crafts.com
A good resource for apothecary and glass bell jars.

Tohickon Glass Eyes
www.tohickonglasseyes.com
Specializing in a wide range of commercial and custom glass eyes.

Van Dyke's
www.vandykestaxidermy.com
A full line of taxidermy forms, eyes, tools, and kits, including Jonas Supply products. Part of the McKenzie family of companies.

Wasco Wildlife Artist Supply Company
www.taxidermy.com
A source for taxidermy booklets, manikins, tools, and art supplies. Part of the McKenzie family of companies.

LEGAL RESOURCES

Below are the websites that explain the laws governing animal stewardship. To learn more about the key legislations that affect taxidermy, see pages 10–12.

Animal Legal and Historical Center
www.animallaw.info

U.S. Fish and Wildlife Service
www.fws.gov

KEY LEGISLATION

Bald and Golden Eagle Protection Act
www.fws.gov/midwest/midwestbird/eagle
permits/bagepa.html

**Convention on International Trade in
Endangered Species of Wild Fauna
and Flora (CITES)**
www.cites.org

Endangered Species Act
www.fws.gov/endangered/species/us-species
.html

Fur Product Labeling Act
www.ftc.gov/os/statutes/textile/furact.shtm

Lacey Act
www.fws.gov/international/laws-treaties-agree
ments/us-conservation-laws/lacey-act.html

Marine Mammal Protection Act
www.nmfs.noaa.gov/pr/laws/mmpa/

Migratory Bird Treaty Act of 1918 (MBTA)
www.fws.gov/migratorybirds/Regulations
Policies/mbta/mbtandx.html
www.fws.gov/laws/lawsdigest/migtrea.html

STATE DEPARTMENTS OF NATURAL RESOURCES

Alabama
Department of Conservation and Natural
Resources
www.dcnr.state.al.us

Alaska
Department of Natural Resources
www.dnr.alaska.gov

Arizona
Game and Fish Department
www.azgfd.gov

Arkansas
Game and Fish Commission
www.agfc.com

California
Department of Fish and Wildlife
www.dfg.ca.gov

Colorado
Department of Natural Resources
www.dnr.state.co.us

Connecticut
Department of Energy and Environmental
Protection
www.ct.gov/deep

Delaware
Department of Natural Resources and Environ-
mental Control
www.dnrec.delaware.gov

The District of Columbia
District Department of the Environment
www.ddoe.dc.gov/service/fisheries-and-wildlife

Florida
Fish and Wildlife Conservation Commission
www.myfwc.com

Georgia
Department of Natural Resources
www.gadnr.org

Hawaii
Department of Land and Natural Resources
www.dlnr.hawaii.gov

Idaho
Department of Fish and Game
www.fishandgame.idaho.gov

Illinois
Department of Natural Resources
www.dnr.illinois.gov

Indiana
Department of Natural Resources
www.in.gov/dnr

Iowa
Department of Natural Resources
www.iowadnr.gov

Kansas
Department of Wildlife, Parks and Tourism
www.kdwpt.state.ks.us

Kentucky
Department of Fish and Wildlife Resources
www.fw.ky.gov

Louisiana
Department of Natural Resources
www.dnr.louisiana.gov

Maine
Department of Inland Fisheries and Wildlife
www.maine.gov/ifw

Maryland
Department of Natural Resources
www.dnr.state.md.us

Massachusetts
Department of Fish and Game
www.mass.gov/eea/agencies/dfg

Michigan
Department of Natural Resources
michigan.gov/dnr

Minnesota
Department of Natural Resources
www.dnr.state.mn.us

Mississippi
Department of Wildlife, Fisheries and Parks
www.mdwfp.com

Missouri
Department of Natural Resources
www.dnr.mo.gov

Montana
Department of Natural Resources and
Conservation
www.dnrc.mt.gov

Nebraska
Department of Natural Resources
www.dnr.nebraska.gov

Nevada
Department of Conservation and Natural
Resources
www.dcnr.nv.gov

New Hampshire
Fish and Game Department
www.wildlife.state.nh.us

New Jersey
Division of Fish and Wildlife
www.state.nj.us/dep/fgw

New Mexico
Energy, Minerals and Natural Resources
Department
www.emnrd.state.nm.us

New York
Department of Environmental Conservation
www.dec.ny.gov

North Carolina
Wildlife Resources Commission
www.ncwildlife.org

North Dakota
Game and Fish Department
www.gf.nd.gov

Ohio
Department of Natural Resources
www.ohiodnr.gov

Oklahoma
Department of Wildlife Conservation
www.wildlifedepartment.com

Oregon
Department of Fish and Wildlife
www.dfw.state.or.us

Pennsylvania
Game Commission
www.pgc.state.pa.us

Rhode Island
Division of Fish and Game
www.dem.ri.gov/programs/bnatres/fishwild

South Carolina
Department of Natural Resources
www.dnr.sc.gov

South Dakota
Game Fish and Parks
www.gfp.sd.gov

Tennessee
Wildlife Resources Agency
www.state.tn.us/twra

Texas
Parks and Wildlife
www.tpwd.state.tx.us

Utah
Division of Wildlife Resources
www.wildlife.utah.gov

Vermont
Fish and Wildlife Department
www.vtfishandwildlife.com

Virginia
Department of Game and Inland Fisheries
www.dgif.virginia.gov

Washington
Department of Fish and Wildlife
www.wdfw.wa.gov

West Virginia
Division of Natural Resources
www.wvdnr.gov

Wisconsin
Department of Natural Resources
www.dnr.wi.gov

Wyoming
Game and Fish Department
www.wgfd.wyo.gov

Anthropomorphic taxidermy: Taxidermy mounts with human qualities, like standing on two legs, dressed in human clothing, or performing human tasks.

Beam: A wooden log raised on one side, over which a skin can be placed in order to flesh it.

Beaming knife: A wide two-handled knife used to flesh a skin, usually used with a beam.

Botched taxidermy: A term coined by Steve Baker in reference to taxidermy that was improperly made, due to limited visual reference, skill, or preference.

Brain soup: The mixture of brain and water used to brain tan a skin.

Breaking a skin (softening): The process of taking the newly tanned hide and breaking the fibers to create a soft finish.

Cape: A hide consisting of just the neck, shoulder, and head, for mounting.

Chimera: Any fictional or mythical animal made up of parts of several animals. It takes its name from a beast in Greek mythology that had the heads of a lion, a snake, and a goat.

Defatting: Removing extra fat in the tanning process. This is especially necessary in fatty birds and fur-bearing mammals.

Desiccation: Also known as mummification, the process of extreme drying out of a material, skin, or flesh due to cold, salt, or heat.

Dime museum: A collection of popular, lowbrow exhibits including oddities, gaffs, and freaks, with a low admission price.

Drumming: When a hide dries out improperly on a form. The skin stretches along the indentations of the form and tightens to form a drum. This can lead to the fur splitting.

Dry preserving: The process of using a mixture of chemicals to disinfect, discourage bugs, and preserve the skin as it dries.

Dry tan: A pelt that has been taken all the way through the tanning process to the point where it is dried. It will need to be rewetted before mounting.

Esodermy: The process of using desiccation to preserve just the muscle and bones, not the skin.

Feeders (feeder animals): Animals that are raised as a food supply for domesticated carnivores (like lizards, snakes, raptors, etc.).

FeeJee mermaid: A traditional gaff often made up of a fish tail and a primate body.

Fleshing: Cutting off the remaining flesh and fat from a skin.

Fur dresser: A professional tanner.

Gaff: Originally used to describe a prop used to fool the audience in a sideshow act, it is also a term for an organic hoax or faked oddity (such as a FeeJee Mermaid or shrunken head) used to draw a crowd into a show, like the fishing hook of the same name.

Humbug: A person or an object whose intent is to deceive, trick, or mislead.

Jackalope: A traditional American gaff, which consists of a shoulder-mounted rabbit with deer or antelope antlers.

Jenny Haniver (Jenny Haviers): A traditional gaff in which a dried skate or ray has its wings cut to form a devilish human creature.

Masterclass/Gamefeed: A taxidermy demonstration in which whatever animal is skinned and mounted is also prepared and served as food.

Mounting: Putting a prepared hide on a form.

Mummifying: The process of preserving remains through the process of desiccation, either with excessive cold or heat.

Neutralizing: A stage in the tanning process by which one removes the acid introduced in the pickling stage so that the skin can accept the tanning solution.

Oiling: A step in the tanning process that keeps the collagen fibers from hardening after a hide dries.

Ossuary: A space or object that holds human skeletons and bones.

Osteology: The study and preservation of bones.

Pickle: A tanning mixture of acids and water, used to remove fat and soluble proteins.

Pickling: The process of soaking a skin in an acid solution to remove fat.

Plastination: The process for making the specimen "plastic" on a cellular level. This is done by drawing water out of cells at freezing conditions and replacing it with acetone. The specimen is then boiled at a low temperature to evaporate the acetone, which is then replaced by liquid plastic. Finally, the liquid plastic hardens to create a solid specimen.

Rogue Entomology: A branch of entomology that prepares insects, especially beetles, in whimsical anthropomorphic dioramas.

Rogue's gallery: An exhibition of criminal photographs, weapons, torture devices, clothing, ephemera, and any other objects associated with murder.

Rogue Taxidermy: A genre of Pop-Surrealist art characterized by mixed-media sculptures containing traditional taxidermy materials used in an unconventional manner.

Rug: A hide skinned and prepared to lay flat (which differs from a hide intended for mounting).

Salting (salt curing): The process of covering every part of the skin with salt in order to dehydrate and prepare the skin for tanning.

Shaving: The process of thinning out the flesh on the inside of the hide to a uniform thickness.

Slippage: Hair loss due to spoiling of meat, oversoaking, or improper tanning.

Splitting: The process of cutting parts of the skin—such as ears, lips, and tails— that contain pockets of meat which could spoil later if not removed.

Stuffing: Putting bread and vegetables in a turkey before cooking (not a term to be used in reference to taxidermy, as it is considered derogatory).

Swamp boogie: A traditional gaff and taxidermy joke wherein a deer's butt is mounted over a human face form.

Tanning: A series of steps, including salting, rehydrating, pickling, shaving, neutralizing, defatting, tanning, oiling, and breaking, that changes the character of a hide, making it stable, soft, and pliable.

Taxidermist: Someone who practices taxidermy.

Taxidermy: The process of mounting and stuffing dead animals.

Totem: An object or symbol that represents an animal or plant used by a group of people to self-identify.

Trophy mount: A taxidermy mount made from an animal that was hunted, for the purpose of displaying as a memorial to the hunt.

Tumbling: Repeatedly turning a skin over in sawdust as a means of drying.

Turning ears: Inverting the ears on a hide before salting so that the salt can properly coat everything, preventing hair slippage.

Vegan taxidermy: Artificial materials used to create a facsimile of an animal specimen.

Wet preserving: The process of preserving any combination of muscle, organs, bones, and skin by suspending them in a clear jar with a translucent liquid (like alcohol) for the purpose of display and further study.

Wet tan: A pelt that has been taken through the tanning process but not dried. It is moist and can be mounted right away or stored frozen.

Wolpertinger: A traditional Bavarian gaff that is a combination of small mammal body with wings, antlers or horns, and fangs.

ACKNOWLEDGMENTS

I n 2004, a small exhibition opened in northeast Minneapolis, establishing the Minnesota Association of Rogue Taxidermists (MART). To this day, I cannot express enough my appreciation for the humor, artistic impulses, and friendship that Sarina Brewer and Scott Bibus have shared with me over the years. There is no doubt that without them there would be no *Taxidermy Art*—and in fact, no Rogue Taxidermy.

I would like to thank Lia Ronnen for believing in me and in this project enough to help it see the light of day. Bridget Heiking worked diligently with me on a daily basis to mold my ramblings into comprehensible ideas. Teagan White's illustrations brought such beauty to historical figures and the gory elements of the workshops. Michelle Ishay-Cohen and Kara Strubel gave form and design to the project to create a true art piece. Thank you to them, Jen Renzi, and the rest of the Artisan team for bringing out the best in this book.

The artists in this book were willing to go on an adventure with me and for that I will be forever grateful. They were amazing travel companions, serving as Sherpas, translators, drinking buddies, hosts, crazed mountain sages, rickshaw drivers, buttoned-up explorers, and friends. I could not have made this guidebook without their artistic vision and willingness to share it with me and the world.

Thanks to my friends who generously hosted me during my travels, in cities near and far: the Hillam-Dunn clan; the Smith-Pollock clan; the Maurios; Antonella Focarino and the boys, Harris Feinsod and Emily Licht; Brian Lesteberg and Sarah Fuller; and Stan Katz.

This book came out of lectures and presentations supported and hosted by the University College of London, *Cabinet Magazine*, the Last Tuesday Society, the Congress of Curious people at the Coney Island Sideshow, Guerilla Science, the Morbid Anatomy Museum, Secret Science Club, the Bellhouse, and La Luz de Jesus. Thanks to everyone who spoke with me about this book, especially Petra Lange-Berndt, Joanne Ebenstein, Vadim Kosmos, Jay Kirk, James Mundie, Caitlin Dougherty, Divya Anatharaman, Lupa Greenwolf, James Taylor, Leon and Maurice Bouten, Jeff and Jane, and Mark Dion. For their help with the workshops, I would like to thank Erich Carter and Katie Innamorato.

I would be amiss not to thank all the people who helped the MART and the Urban Beast Project over the years, including: the Brewers, the Bibuses, Fiona Stiles, Jennifer Kellogg, the Martin's Pretzel crüe, and especially Alfred Milanese, for inspiring me to view art as a practice. And to Tom Murray, for saying "make the book."

Finally, I am humbled to have such an amazing family, who shared in all my joys and trials through this process. Thanks to my mom and dad, for instilling curiosity in me, and to my brothers, who have weathered that same curiosity for forty-plus years; to Barbara Fenhagen for checking in on me, and to André Lee for sharing his artistic journey with me. To Alix, your love, strength, and wonderful calm kept me (and Punch) reasonably sane the past year (and I still can't believe you let me brain tan a squirrel in our house). Thank you.

INDEX

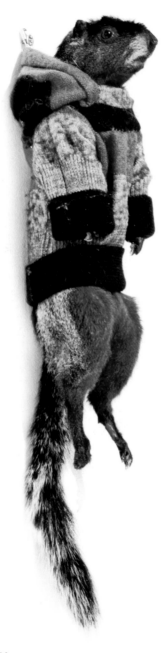

PHOTOGRAPHY CREDITS

All photographs are by Robert Marbury except the following:

Pages 2 and 138–43: Terence Bogue; pages 46–49: Larry Underhill; pages 52 and 54–56: Marijn Vanderheijden, Strictua; pages 53 and 57: Sanne Linssen; page 61: Katie Innamorato; pages 66–67: courtesy of Other Criteria; pages 68–69: Tessa Angus; pages 70–71: Polly Morgan; pages 74–75: Jeremiah Alley; pages 76–77: James Rexroad; pages 86–89: Grant Fraser; pages 92–95: Stephan Rabold; pages 98–100 and 102–3: courtesy of Claire Morgan and Galerie Karsten Greve, Cologne, Paris, St. Moritz; pages 106–9: courtesy of Mark Dion and Tanya Bonakdar Gallery, New York; pages 112–15: Kate Clark; pages 118 and 124–25: Matthew Welby, courtesy of Tessa Farmer and Danielle Arnaud, London; pages 120–22: Sean Daniels, courtesy of Tessa Farmer and Danielle Arnaud, London; page 123: Tessa Farmer, courtesy of Danielle Arnaud, London; page 126: Vernon Winn; pages 130–31: Mirmy Winn; pages 134–35: Lucy Hamblin; pages 146–48: Charles Howells; page 149: Lisa Black; pages 150–51: Evie Mackay; pages 154–57: courtesy of James Prosek and Schwartz · Wajahat, New York; pages 160–65 and this page: The Idiots.

Hangjongeren